Warhorses of Germany

THE MYTH OF THE MECHANISED
BLITZKRIEG

Warhorses of Germany

PAUL GARSON

AMBERLEY

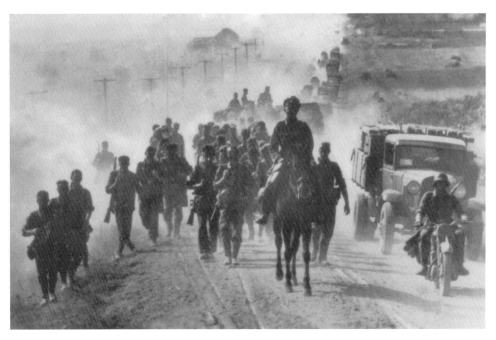

March into Oblivion
Led by a solitary officer on horseback, an unending convoy of German foot soldiers and trucks create a dust storm along a Russian road in the summer heat of June 1941. Few of the men or horses would ever return home.

First published 2018

Amberley Publishing
The Hill, Stroud
Gloucestershire, GL5 4EP

www.amberley-books.com

Copyright © Paul Garson 2018

The right of Paul Garson to be identified as the Author
of this work has been asserted in accordance with the
Copyright, Designs and Patents Act 1988.

British Library Cataloguing in Publication Data.
A catalogue record for this book is available from the British Library.

ISBN 978 1 4456 7250 2 (print)
ISBN 978 1 4456 7251 9 (ebook)

Origination by Amberley Publishing.
Printed in Great Britain.

Contents

About the Author

Paul Garson is a freelance journalist and photographer based in Los Angeles, California. He has also written *Two-Wheeled Blitzkrieg* for Amberley Publishing and five additional fiction and non-fiction titles for publishers such as Doubleday and Simon & Schuster, as well as more than 2,500 magazine articles for publications including the *Los Angeles Times*.

Introduction

While early man initially regarded the wild horse as a food source, after its domestication some 5,000 years ago it then served not only as a work tool and means of transportation, but eventually as a weapon of war, before again becoming a food source due to the carnage of the world wars.

Many films have attempted to convey the experience of the Second World War European battlefield, but none adequately portray the mayhem and suffering that befell untold thousands of horses, their bodies being impacted by bullet, flame and bomb as well as disease, starvation and backbreaking toil in the searing heat of summer and the freezing winds and snows of winter. In great part, the role of the horse in warfare, and in particular its use by the Third Reich, has been eclipsed by the *sturm und donner* of Panzers and Stukas – the iconic images of the German mechanised blitzkrieg. In reality, the so-called 'military juggernaut' was a myth, with the Nazi war machine being more horse flesh than mechanism.

Germany is known for a large number of long-standing and also relatively recently established horse breeds, including the Aegidienberger, Altwurttemberg, Arenberg Nordkirchener, Bavarian Warmblood, Black Forest Horse, Brandenburger, Dülmen Pony, East Friesian Warmblood, German Cold Blood, German Reitpferd, German Riding Pony, Hanoverian Horse, Hessen Horse, Holsteiner, Lewitzer Pony, Mecklenburg Horse, Oberlander, Oldenburger, Rhine Cold Blood, Rottaler, Sachsen Warmblood, Saxon Turinga, Saxony Warmblood, Schleswiger Draught, Senne Horse, Lehmkuhlener Pony, South German Coldblood, Westfalen Pony, Württemberger, and Zweibruker.

In general, horses can be divided into two categories: warmbloods and coldbloods (the latter in part named because they are more difficult to spook than smaller horses, which is an advantage in warfare). Both types contain several breeds as developed within individual countries that were designed for specific tasks. For example, the stout, draught-sized coldblood horse, large and gentle of disposition, initially cleared farmlands or pulled city carriages. German coldblood breeds include the Black Forest Chestnut (*Schwarzwälder Kaltblut*), the Friesian, Haflinger and Percheron. In contrast, coldbloods were 'streamlined' into warmbloods, with lighter, more athletic builds for sporting events, including racing. German warmblood breeds include Groningen, Holsteiner, Oldenburg, Hanoverian, Lipizzaner and Trakhener. Joining the coldbloods

were the thoroughbreds, which were first developed in England from Middle Eastern stock and which excelled in speed and stamina, but were of a higher strung temperament than the coldblood draught animals.

While many breeds would later fall out of favour, and thus become endangered in the late twentieth century as modern mechanisation took hold, others would be impacted by the world wars. They included the aforementioned Holsteiner. One of the oldest, and bred specifically for enlistment in warfare, they originated from the stock of Elmhorn marsh horses. Another was the Dülmen Pony, which can be traced back some 600 years and has been kept original, in the sense that they were not impacted by human efforts at interbreeding. The Dülmen shared a particular genetic trait that caused almost all of the breed to appear as Grullo (grew-ya) or tan-colored. A third breed developed for warfare was the Hanoverian, linked to King George II of England who bred horses in the area of Hanover by bringing together Holsteins, thoroughbreds and Andalusians, the new breed initially intended for agricultural and coach work. By the early nineteenth century, they assumed their military role in Europe, including Germany. Another warhorse was the Friesian, originating in the Netherlands as a light draught horse. In the medieval period the Friesian was repurposed to carry knights in armour, and from then served as warhorses in future wars.

Horses and mules were an integral part of life in Germany, pervasive implements in agriculture and industry as well as a source of personal enjoyment in leisure and sport competition. Though never termed a weapon, 'the *Kriegspferde* or *Schlachtross* (warhorse) would also become a major constituent of the Third Reich's war efforts and in the end [was] consumed en masse, as it were, as cannon fodder'.

Visually chronicling the role of the German warhorse, the following original photos were in most part taken by German soldiers using their personal cameras to record their relationship with their four-legged comrades, as well as the suffering and death they shared in a war that showed no mercy to any living thing, be it man or beast.

Illustrated magazines of the day often created a semi-mythical portrayal of armed conflict, especially during wartime, when public morale and patriotism were involved. A romantic conception of the classic cavalry charge with swords flashing and beautifully groomed horses at the gallop was hardwired into the military mind-set – a naïve notion that would find mounted soldiers charging into the mouths of modern machine guns with fatal consequences during the First and into the Second World War.

When reading the diaries of cavalry soldiers, one can begin to envision the true scope of the disaster: images of disembowelled and legless animals dragging themselves across the battlefield and left to die slow deaths; uninjured horses being shot out of hand during retreats to keep them from the enemy; horses being forced to work without fodder or water until they dropped, and were in turn consumed themselves by starving soldiers and civilians. During the First World War, over 8 million horses died as the result of wounds, injury, disease, starvation, the weather and exhaustion. Millions more would suffer the same fate in the Second World War.

As a result of the First World War, the size and equipment of the German military was restricted by the Treaty of Versailles. While motor vehicles intended for the military

came under strict control, the treaty allowed for seven infantry divisions and three cavalry divisions consisting of eighteen regiments. In effect, a large part of the post-First World War Treaty of Versailles permitted a German Army strength of 100,000, which consisted of cavalry formations, with some 16,400 mounted on horseback.

The cavalry men carried lances during the transition period, which eventually gave way to carbines. Then, in late 1934, motorcycles entered the picture. The 11th, 12th and 16th Horse Regiments were now motorised rifle troops, who were in effect riding 'iron horses' (principally German-made Zundapp, BMWs and NSUs). Other cavalry regiments were re-equipped as tank regiments, including panzer, anti-tank and reconnaissance units, while the Waffen-SS also fielded cavalry units.

Prior to 1935, and thanks to the staggering twelve years of German military service required for enlisted men and NCOs, some 3,000 hours were afforded to basic rider training. This laid an excellent groundwork for the horse-mounted troops, although as Germany moved toward war, the rider's training time was reduced to an average of one hour per day, with riders now focusing on weapons and combat strategies. Since many of their duties were aimed at reconnaissance, scouting and even assault operations, the horse troopers often endured training regimens requiring 30 to 60 miles per day in the saddle, while each horse was tasked with carrying, often at speed, upwards of 250 lbs of man and equipment.

All horse riders and team drivers also took training in mastering the basic medical needs of their mounts. The extensive support system required a plentiful supply of both blacksmiths and veterinarians to be recruited and made available for the military, which was facilitated by rural Germany's horse-dominated agriculture. Conversely, many of the metropolitan area's auto mechanics who were drafted into the military and encountered a stiff learning curve proved unsuited during their training to deal with military vehicles, thus adding another impediment to overall mechanisation.

However, German military planners had learned from their mistakes of the First World War when it came to horses, realising that they did not have enough horses for the work needed. In preparation for the next conflict, Germany began buying up large quantities of mounts, including many from Britain, where its military planners saw no need for horses as they were certain the next battles would be fought exclusively by modern machines – principally aircraft and the tank – and thus scrapped its cavalry components.

Just two years into the Nazi Party's assumption of power, 1935 marked a milestone for the new Third Reich. Despite the rigorous restrictions of the First World War-imposed Treaty of Versailles limiting Germany's military expansion, Hitler introduced universal conscription – a plan applauded by the general public. In that year, the Luftwaffe, Kriegsmarine and Waffen-SS were also established, while the Saar coal-rich industrial region, essential for the war production effort, was reclaimed without a shot fired.

As the military expanded on all levels, the infusion of horses increased as well. Cavalry mounts were purchased at the age of three. Training began at age four and continued for two more years in a program that was unmatched by any other nation.

Building the Perfect Horse: Third Reich Equine Eugenics

In addition to Nazi Germany's social engineering efforts to produce the ultimate Aryan *Ubermensch,* or 'racially pure' warrior class, via its SS *Lebensborn* (Fountain of Life) project, which was initiated in 1935, a similar program focused on breeding the ultimate warhorse. Among the hundreds of the finest of Europe's horses selected were Arabs, thoroughbreds and the famous snow-white Lipizzaner stallions – the pure-bred 'dancing horses'. Found at the world-famous Spanish Riding School of Vienna, Austria, they were trained under the direction of Colonel Alois Podhajsky, who was also well known for his participation in the 1936 Berlin Olympics, winning a medal in the dressage competition.

As the war ground to an end, the Wehrmacht's special breeding stock had been sequestered at a breeding facility in occupied Czechoslovakia. Then, after US forces captured the Riding School that had been relocated to a small Austrian town, US General George S. Patton, a horse lover, travelled to see them perform their intricate 'ballet' to music. At this point Podhajsky requested Patton's intervention to save his Lipizzaners from impending capture by the Red Army, which was advancing from the East and closing in on Berlin. He feared the rare horses would be sent back to the Soviet Union as farm labour or even be served up as a food source. Patton complied, taking the horses under the protection of the US Army. He then agreed to a secret mission, codenamed 'Operation Cowboy', to rescue the horses as well as the Czech and Polish POWs caring for them before the Red Army captured them all, the area being given over to the Soviets as a result of the Yalta Conference.

A single American officer, Captain Tomas M. Stewart, also a horse lover, was selected to join a German veterinarian to make arrangements for the surrender of the facility. A deal was struck and on 28 April 1945, shortly before the war's end, a peaceful surrender was accomplished. The effort resulted in the rescue of 100 of the finest Arabian horses in Europe along with race horses and trotters, hundreds of the sturdy Russian Cossack mounts and, the ultimate goal, some 250 Lipizzaner. Moreover, 300 American and a number of British POWs were also liberated. All went well until the facility was attacked by German troops, but mostly by old and young *Volksturm* members, and many were captured by the camp's multi-national defenders of Americans, Germans, Czechs, Cossacks and Poles.

The next threat came with the rapid approach of the Soviets, so quick action was called for. Some 350 horses along with American vehicles started off on the 130-mile,

three-day trek to the Western Zone that saw a total of 244 Lipizzaners repatriated safely back to Austria. When asked why so much was risked to save the horses, the US officer in command, Colonel Charles Hancock Reed, a cavalry school instructor, replied, 'We were so tired of death and destruction, we wanted to do something beautiful.'

Released in 1963, the Disney movie *Miracle of the White Stallions* brought the story to the big screen with actor Robert Taylor reprising the role of Podhajsky. The Lipizzaners also appeared in many other movies, television shows, books and periodicals.

The various regions of Germany produced several types of both smaller-framed and larger draught horses. Of the lighter-framed warmblood horses, spirited animals like the Arabian were used for cavalry riding and mounted troops while a number of fleet-footed Berber horses entered Wehrmacht cavalry service after the fall of France. As mentioned, the Wehrmacht utilised the so-called coldblood type for wagon-pulling duties. Bred for size and strength, examples included the Clydesdale and the Black Forest Horse (*Schwarzwalder Fuchs*).

The need for heavy draught-sized horses grew as military wagon loads grew heavier. Unloaded wagons themselves could weigh from 610 to 1,040 kilograms (over 2,200 lbs) and could require four to six horses to pull, especially when encountering what served as Russian roads. As well the horse's own fodder, the draught animals transported food supplies, ammunition, mobile kitchens, medical units, fuel and heavy artillery.

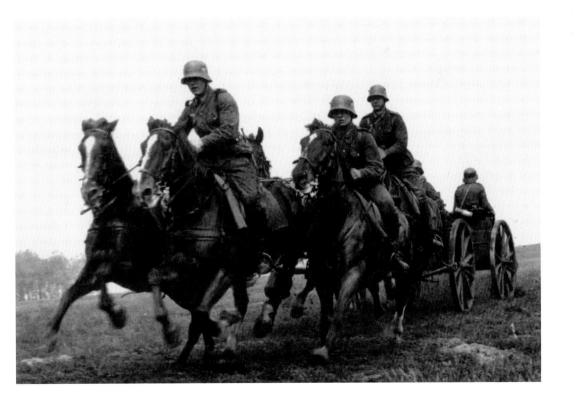

While strong, durable and good natured, many such draught horses were taken from their farm fields to the Front, where they encountered conditions for which they were ill-prepared. The large animals were sensitive to extreme temperatures, required special diets to prosper and were slow moving – an impediment to blitzkrieg. Six large draught horses were needed to haul a German 150 mm artillery gun that, including ammunition, amounted to some 4 tons. However, as the war's ever-expanding attrition rate required, the wrong horse for the wrong job was often pressed into service. In an effort to ameliorate the situation, the German military developed a complex organisation to manage the massive use of horses, which included, for each fielded Army group, three Army horse hospitals, two Army horse parks designed to hold reserve animals and one veterinary examination station. In the end it would amount to too little too late.

As of 1935 a cavalry platoon assigned to each active infantry regiment was comprised of thirty-two men and thirty-three horses. In addition to thirteen other regional riding schools, a special cavalry school operated in Hanover for replacement officers and for both vehicle-driving and riding instructors, with women taking over the instruction duties in many cases, especially later in the war.

German riding schools prided themselves as trainers of horses and riders of the highest quality, and from 1930–40 competed in every important international event. Their crowning achievement came at the pre-war 1936 Berlin Olympics, when the German national team, all Army personnel, won all six gold medals and one silver, dominating the three disciplines of dressage, jumping and military – a feat that has never been repeated.

By 1939, and preparing for imminent war, the German military counted some 2.74 million men in uniform, 183,000 motor vehicles, 94,000 motorcycles and 514,000 horses.

Because production of steel and iron could not keep pace with the expansion of the mechanised military, horse flesh filled the gap. Subsequently, when war did begin with the invasion of Poland on 1 September 1939, only fourteen of Germany's fifty-five divisions were fully motorised. At this point the German Reich possessed 3.8 million horses, of which 885,000 were initially called to the Wehrmacht as saddle, draught and pack animals. An additional 435,000 horses were eventually captured during the campaigns against Poland, France and the Soviet Union. Still more horses were purchased from Hungary, Romania, Czechoslovakia and Ireland.

Horse-mounted troops served strategic roles, including frontline combat, reconnaissance, communications and anti-partisan warfare, as they were often able to traverse topography inaccessible to mechanised forces. SS and Police Cavalry units also hunted down Soviet Army stragglers, led so-called 'atonement actions' (destroying villages and their populations suspected of harbouring or supporting partisans) and also took part in the round-up and mass murder of Jewish civilians.

In 1937, *Reichsführer-SS* Heinrich Himmler established a riding school for soldiers of the *Allgemeine-SS* in Munich. Known in Germany as *SS-Hauptreitschule München*, only sons of German nobility or industry leaders were invited to attend this elite cavalry school. Emphasising the importance of these efforts, Himmler and other

leaders of the SS and SA visited the school in full ceremonial procession during the pre-war years. Himmler had entrusted SS officer Hermann Fegelein with oversight of the school. Fegelein, married to Eva Braun's sister Gretl, also became Hitler's adjutant during the war. Many troops who attended *SS-Hauptreitschule München* later served in the 8th SS Cavalry Division Florian Geyer, under the command of Fegelein.

While the Wehrmacht was initially the least modernised of the European armies, the Third Reich propaganda created a distorted image of the true state of affairs. One contributing factor was that 1930s Germany was not supported by a strong automobile or even farm tractor infrastructure that could be militarised for war production, nor were its people 'automobilised' to any great extent. By contrast, the United States' population of 127 million counted one car per five people in 1935 while Germany's population of 67 million counted only one car per eighty-nine people.

In an effort to augment its mechanisation efforts during the war, the German military utilised captured Czech and French machines, but there was a language problem when dealing with manuals for the former and a lack of reliability with the latter, especially when facing the demands of the Eastern Front. Compounding the dilemma were the 2,000 kinds of vehicles that eventually took part in the invasion of the Soviet Union – the complexity and variation creating a maintenance and parts resupply nightmare. In addition, as the war of attrition ground on in the East, the logistics requirements projected the demand for an additional 2,700 trucks, which could not be supplied, thus horses again made up for the shortage. In the end, the 9,000 captured French horses proved more durable than its requisitioned vehicles.

The German cavalry corps, which in wartime would consist of horse, bicycle and motorcycle troops, contained eighteen horse regiments. Initially disbanded at the outbreak of the war in 1939, they were reformed into divisional reconnaissance battalions that were followed in 1943 by what is considered to be the rebirth of the German Cavalry, which began with three regiments.

A cavalry brigade consisted of 6,684 men and 4,552 horses plus 409 horse-drawn vehicles and 318 motorcycles (153 with sidecars), as well as 427 cars and trucks and 6 armoured scout cars. After their success in the 1939 Polish campaign, the 1st Cavalry Division (*1. Kavallerie-Divison*), which had been disbanded after the First World War, was reformed on 25 October 1939, several weeks after the invasion of Poland. The cavalry division, with its motto *Sieg Heil,* would go on to fight in Holland, Belgium and France during 1940.

When the time came to attack Russia during Operation Barbarossa, which was launched on 22 June 1941, the division subsequently came under the command of *Panzergruppen* 2 (Guderian). At this stage, some 17,000 horses were employed, with the sheer number causing supply problems. Then, during the record-breaking severe winter of 1941/42, cavalry operations ceased. The division reformed as 24th Panzer Division and its specially trained horses were reassigned to other non-cavalry units, where they were effectively squandered.

While the speed of the mechanised German military won early victories, the inability to produce the needed volume of war machines, plus the failure to supply the vast amounts of fuel and spare parts combined with the slowness of the horse-transported

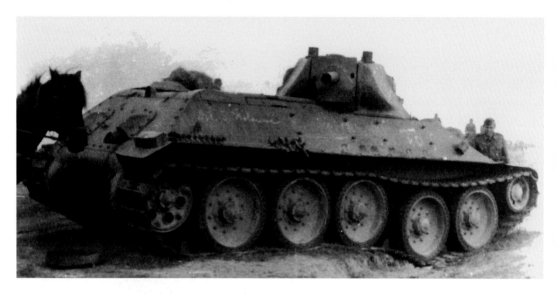

supplies when facing the wide expanses of the Soviet Union, proved a formula for ultimate failure. In the final analysis, the reliance on horsepower, though it often saved the day, could not keep pace with the ever-increasing demands of modern warfare and only served to compound the incomprehensible level of death and destruction, human and otherwise.

Nevertheless, as Klaus Christian Richter, a member of the 1935 German cavalry class, states in his book *Cavalry of the Wehrmacht 1941–45* when commenting on the physical and psychological stress of the war, 'The old soldierly virtues proved themselves once more: courage, sense of duty, feeling of responsibility, comradeship, and as well, love of the horse.'

The Photos

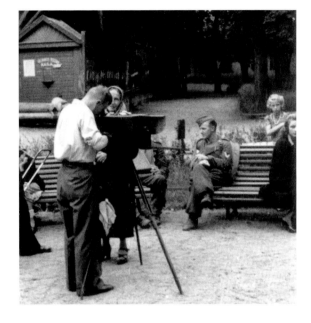

**Photo-Postcard in Progress –
1940 Germany**
A combat-decorated corporal in
the mechanised forces shares a park
bench as a photographer sets up his
special photo-postcard processing
camera as an unseen cameraman
captures his image.

Warhorses of Germany features original, mostly never-before-seen images, with
the photographs having been sourced from Germany, Austria, Spain, Italy, Great
Britain, France, Russia, Ukraine, Canada and the US. Considering the fragility of
these mere slips of paper, and the often violent environment in which they existed,
their survival is remarkable. Their condition, as well as the quality of the images,
depended on the camera, the photographer and their passage through the decades
to the present recovery, where they serve as virtual time machines – each capturing a
unique fragment of time and history. The author reviewed several hundred thousand
photographs in order to compile this and its companion volumes. Images were chosen
for their intrinsic composition and visual impact, as well as their place within the
historical context, all toward an effort to shed light on those darkest of times. Any
errors of identification are the author's responsibility and he welcomes comments and
clarifications from readers.

During the twelve-year reign of the Third Reich (1933–45), German photographers, both professional and amateur, enjoyed an extensive range of cameras, which were at the time regarded as the best in the world. The most advanced brands included Agfa, Exakta, Leica, Rollieflex, Voigtlander, and Zeiss Ikon. Film types available included both roll and 35 mm, including colour slides. Excellent 8 mm and 16 mm movie cameras were also available from German makers such as Siemens and Agfa, as well as the Swiss-made Bolex.

As a result of the advanced technical nature of photography and the German soldier's proclivity for documenting his military service on film, often creating large and well-notated albums, the sheer mass of war-related images is staggering. In effect, no war, prior to television and the Internet, has been so extensively documented from a personal perspective. The surviving images serve both to record a particular individual's experiences but also provide an all-encompassing overview of the progress of the war, the effects on the Home Front and the countries ravaged by violent invasion, all the while documenting a level of carnage that exceeds description.

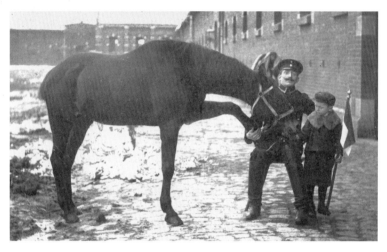

'Pferd gibt Plotchten': Photo-Postcard – 13 March 1906
At a German military base, a cavalryman poses for the photographer with his horse and son, the photo then being sent as a postcard to an address in Dresden. The German word *Pferd* variously translates to horse, knight, and vaulting horse.

Also occurring in 1906 was an odd incident that brought German blind military obedience into national focus. A fifty-seven-year-old German shoemaker, Wilhelm Voigt, disguising himself in a captain's uniform, walked up to a troop of soldiers and ordered them to follow him 20 miles to the town of Tegal, where he had them storm the mayor's office and arrest him. In the process Voigt took the opportunity to abscond with several thousands in cash. He then had the soldiers escort the mayor to Berlin, at which point Voigt made his escape, leaving the soldiers holding the bag, so to speak. Eventually the hoax was discovered and Voigt was arrested. However, Kaiser Wilhelm thought the whole thing amusing and saw to it that Voigt's four-year prison term was shortened to two, and as a result the bold thief was released in 1908, with Voigt then becoming a folk hero of sorts. He wrote a successful book, was the subject of a play and even several films, including an English version starring Paul Scofield as Voigt. His figure was sculpted and also displayed in Madame Tussauds in London, and he posed for photos for many years before his story faded into obscurity, but the German attachment to uniform and blind obedience did not.

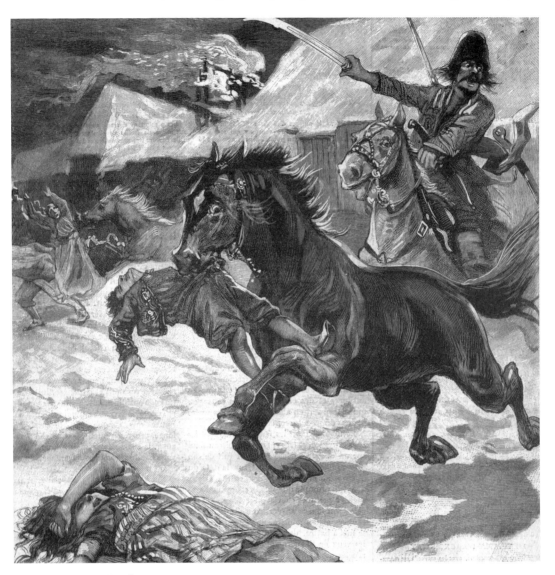

'Horse Men Stealer' – 1907

This rather lurid illustration appeared in a French illustrated magazine and purports to show the practice of Turkoman tribal raids in Persia employing horses trained to capture prisoners in their jaws. The area was plagued by such attacks in order to supply the Central Asian slave trade markets in Khiva and Bukhara. Through them passed tens of thousands of Persian and Kurdish slaves as well as thousands of Russians captured by the raiders. When Tsar Nicholas sent military forces to intervene and rescue the Russian prisoners, they met their destruction when engulfed by a severe winter's storm. However, a lone British envoy, oddly enough named Shakespear, managed to convince the ruling Turkestanean Khan to release the Russian nationals in order to prevent further military invasions. His efforts provided for the release of 416 slaves; however, the practice itself would not end until 1920, when the new Soviet government gained control of the area, which is now known as Uzbekistan.

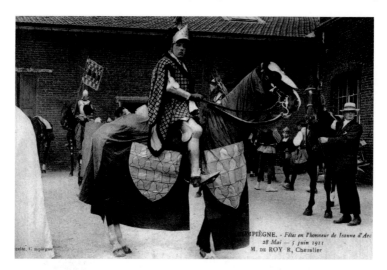

Armoured Horse: Photo-Postcard, Compiègne, France – 1911

In the summer of 1911, the spectacle of mounted knights and their warhorses was a highlight of the third annual staging of the Compiègne Festival, honouring Joan of Arc, the 'saviour of France'. The event celebrated the exploits of the young French woman, who, claiming heavenly guidance, led French forces against England during the later part of the Hundred Years' War. In the battle near Compiègne, south of Amiens, she was captured by local Burgundians on 18 June 1430 and sold to the English, who burned her at the stake on charges of heresy. Compiègne was also the site of the signing of both the First World War Armistice after the German defeat and the French Armistice after Germany's victory over France during the Second World War.

Straight and True: *Reichswehr* **Horse-Drawn Artillery Unit at a Gallop**

A cameraman has recorded the scene sometime in 1913 outside Cologne, the owner of the photo identifying himself with an 'x' and the German notation 'straight and true', apparently regarding his riding posture and perhaps his dedication to duty.

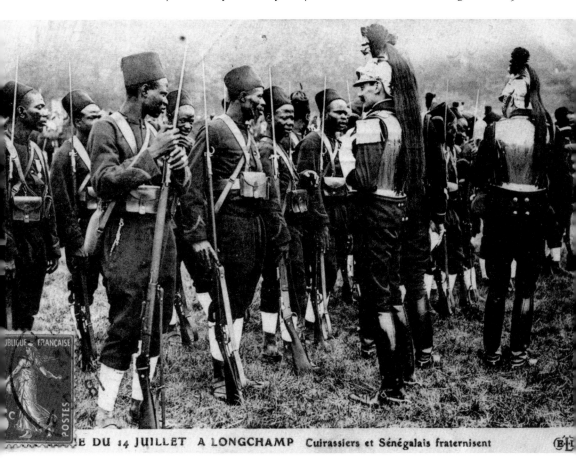

E DU 14 JUILLET A LONGCHAMP Cuirassiers et Sénégalais fraternisent

Anachronism – French Cuirassier – Armoured Cavalrymen

Wearing their nineteenth-century polished metal breastplates and horse-hair plumed helmets, the 'knightly' soldiers appear on a 1916 French postcard celebrating the annual 14 July Bastille Day (French National Day) event held in Paris on the fields of Longchamp. The horsemen are shown 'fraternising' with French Colonial soldiers recruited from Senegal, who fought for France in both world wars.

First formed in the late fifteenth century by several countries as well as France, the 'armoured cavalry', while later equipped with pistols, still favoured and relied on their swords. Their battlefield actions reached their height in the Napoleonic (1803–15) and Franco-Prussian (1870) wars. In 1914, France, Germany and Russia fielded regiments of *cuirassiers*, but only the French retained the distinctive breastplates (if only for a few weeks before the new world war as its lethally modern weaponry made them obsolete). Later, during the Second World War, the *cuirassier* was assimilated *in toto*, being transformed into mechanised units. Currently, one regiment serves in the French Army while other units, dressed in their historic armour, still appear in various Spanish, British, Italian, Chilean and Argentinean ceremonial functions.

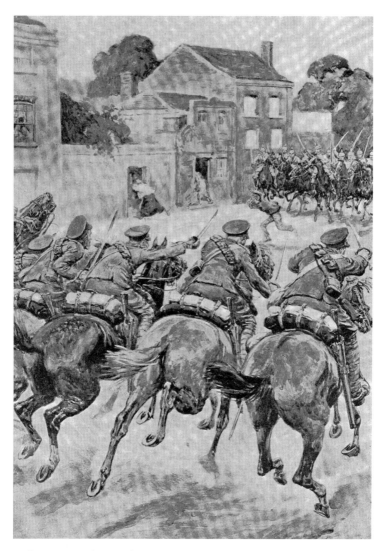

German Cavalry vs. British Cavalry: 'A Proper Cavalry Charge' – 1914
As civilians dash for cover, opposing horse troops – hooves flying, sabers flashing – meet head-on, the event recorded by a full-page illustration in the 12 October 1914 issue of the New York weekly published world-news periodical *The Independent*. It captures one of the rare British cavalry charges of the First World War. The caption for the image reads: 'The Stirring Things That Still Happen Even in Scientific Warfare.'

The commentary that followed stated: 'In spite of the huge siege guns and the leviathan battle-lines, the sharp, sudden, hand-to-hand skirmishes between men on foot, and men on horses still occur.'

The *London Daily Express* repeats the story of this clash in a village of northern France, as told by a wounded British Hussar: 'We came plump on them round a corner in a little village … Absolute surprise for both of us. Before you could wink we were flying at one another as hard as the horses could go, and the villagers were yelling and scrambling into the houses on either side of the road. There was no firing. It was absolutely a proper cavalry charge, like you see in the pictures – horses going hell-for-leather and every man sitting hunched up under the No. 1 guard and hoping he wouldn't get his knees crushed by the fellows on each side of him.'

Cossacks *Chargent* – 1915
A French newspaper feature appearing on 19 September 1915 carried the following description of its First World War Russian cavalry allies charging German troops: 'Among the volunteers engaged by the Army, Squadron 'partisan hussars' deserves special mention. Their commandant W. von Schneouhr has led them as far as Dorna-Watra Bukovina where they fought on foot and horse, throughout displaying the wildest bravery.'

British Field Marshal Kitchener Greeted by French General Baratier: Two High Ranking Casualties of the First World War – 1915
The two military leaders appeared on the cover of the 29 August 1915 issue of the Paris-published Sunday illustrated newspaper *Le Miroir*. The publication offered to 'pay any price for photographic documents of special interest relating to the war', and also offered a long-running contest with cash prizes for the best photograph. In this case the winning image captures the meeting in the field of Britain's Lord Horatio Kitchener and France's Albert Baratier, the latter mounted on a warhorse that seems to have detected the cameraman, glancing in his direction. While aboard a warship on its way to negotiations in Russia, Kitchener was killed when the ship struck a German mine on 5 June 1916, dying at age sixty-five. General Baratier was killed in the front line trenches on 17 October 1917, aged fifty-three.

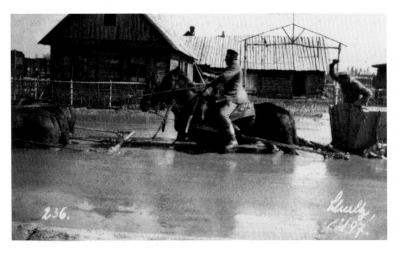

Deja-vu Russian Mud-Floodwaters
German soldiers attempt to wade their horse-drawn wagon through the Russian bi-seasonal thaw known as *Rasputitsa*, resulting in rivers of mud that would also plague German invaders of the Soviet Union in the next war.

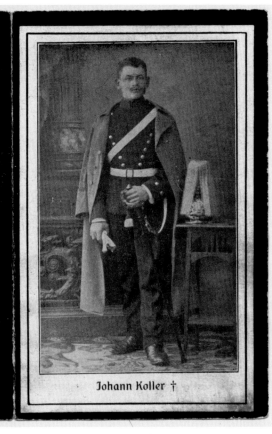

Zur frommen Gebetserinnerung
an den ehrengeachteten
Herrn Johann Koller,
Gefreiter der Reserve
beim 4. Chevaulegerregiment,
4. Eskadron,
welcher am 16. Sept. 1916 durch
einen Kopf- und Brustschuss im
Alter von 31 Jahren den Heldentod
fürs Vaterland starb.

Er ruhe im Frieden!
Ehre seinem Andenken!

O weine nicht! Sieh', wie die Jahre schwinden;
Auch Dich trägt bald ein Engel zu mir her;
Du wirst mich selig unter Sel'gen finden,
Und ewig trennt uns dann kein Sterben mehr;
Drum hebe fromm zu Gott Dein Angesicht
Und weine nicht!

Jesus, Maria, Joseph! (7 Jahre und
7 Quadragenen Ablass.) Pius X.,
16. VI. 1906.

Buchdruckerei A. G. Passavia Passau.

Johann Koller †

Deathcard for a Cavalryman
The traditional Catholic memorial card, or *Sterbebild* (deathcard), announces the fate of Johann Koller, a corporal in the reserve of the 4th squadron of the Bavarian 4th *Chevauleger* (Light Horse Regiment). He died from bullet wounds to the chest and head on 16 September 1916 at age thirty-one.

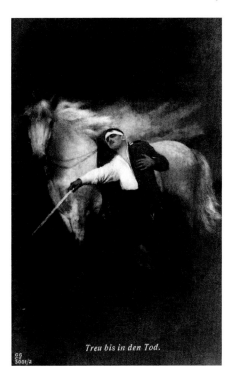

Treu bis in den Tod.

'Loyal Unto Death'
A German postcard depicts a mortally wounded
soldier steadfastly attended by his faithful mount.

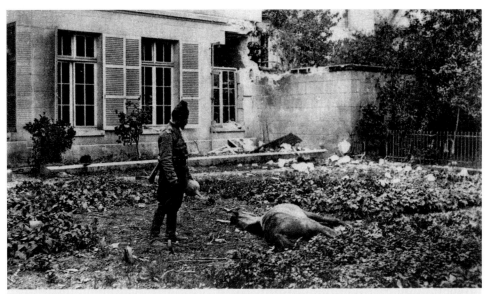

| Chasseur d'Afrique assistant à l'agonie de son cheval | African light horse watching his horse dying |

Dying Friend
The caption, in both French and English, accompanies a photograph showing a French African
Colonial cavalryman standing by his fatally wounded horse, a bomb blasted building in the
background.

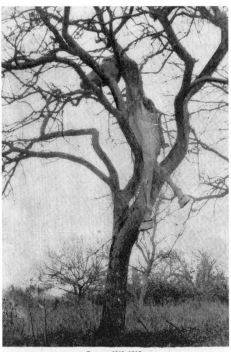

Guerre 1914-1915
Les ravages du 75 - Un Cheval boche projeté sur un pommier

'The Ravages of the 75'

The remains of a horse, blasted into a tree by the shell fired from a 75 mm Howitzer, are identified as German in a French commercial photo-postcard. Posted 22 November 1916, it was addressed with 'friendly greetings' to a recipient in the north-eastern French city of Nancy.

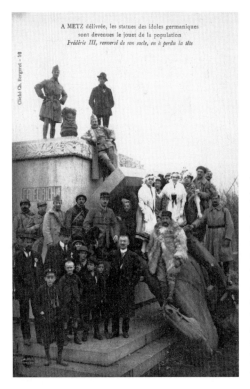

A METZ délivrée, les statues des idoles germaniques
sont devenues le jouet de la population
Frédéric III, renversé de son socle, en a perdu la tête

War Ends: Germany and a Giant Horse Falls – 1918

A French postcard celebrates the Allied victory at Metz with a photo of French soldiers and civilians posing with the toppled horse of German political and military hero Friedrich the Great (1712–86), the King of Prussia. A modern thinker, he sought to unify Germany, and was considered a tactical battlefield genius though his interests lay more in philosophy and music and promoting religious tolerance throughout his realm. Friedrich's favourite horse, a Friesian stallion, was named Conde, who was his last and most famous war mount.

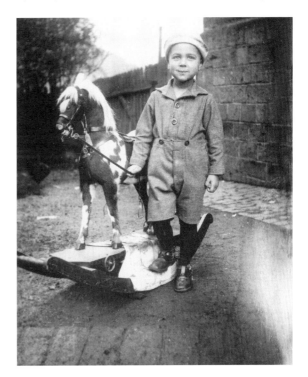

Future *Luftwaffe* Pilot and Hobby Horse – 1924
Notations on the photo indicate that the child grew up to exchange his toy horse for a Messerschmitt or Focke-Wulf, and apparently flew out of the Italian airport in Grottaglie during the upcoming war.

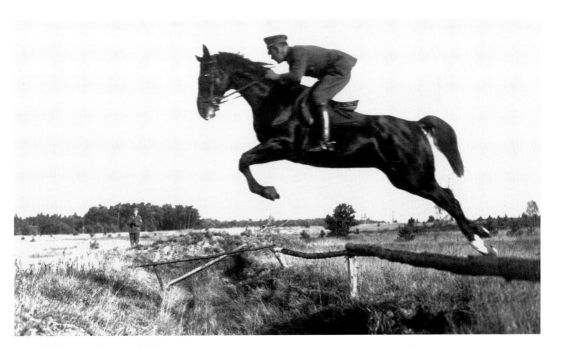

Airborne Between Wars – 1929
Notations on the reverse of this photo identify the rider as Schaefer, a pre-Nazi era *Reichswehr* cavalry officer, seen riding his horse, Cartell, near Wilnsdorf – a city located in the North Rhine-Westphalia area of west central Germany and for centuries a centre for iron ore mining.

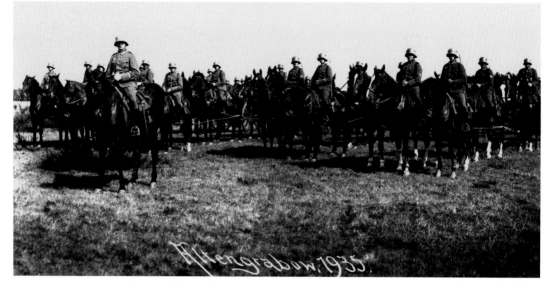

Altengrabow – 1935
Horse-mounted troops of the new Nazi Wehrmacht gather for their group portrait. While the lead officer still carries the classic cavalry saber, his troops are equipped with saddle scabbards for their Mauser rifles. Altengrabow, 90 km southwest of Berlin, had been a German military training area since 1893 and the location of a First World War prison camp. The new war saw the establishment of another *Stammlager*, Stalag X1-A, opened two months after Germany's September 1939 invasion of Poland. Termed a 'work camp', it eventually saw some 60,000 Polish, French, British, Belgian, Serb, Dutch, Slovak and American POWs.

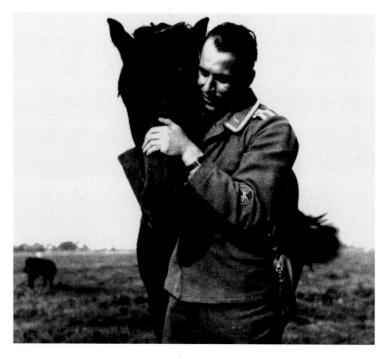

Horse Whisperer
A *Luftwaffe* NCO *Funkmeister*, or radio operator, as indicated by his sleeve patch, communicates with a horse.

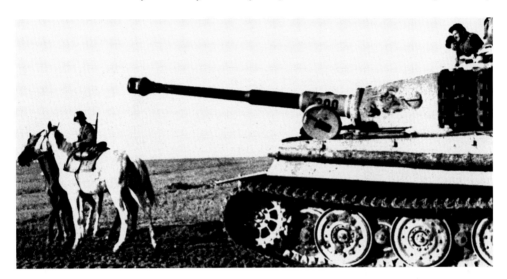

Hooved vs. Tracked
Two cavalry mounts are dwarfed by the intimidating Tiger tank. Contrary to the Third Reich's own massive propaganda programs, and decades of post-war movies that propagated the image of fully motorised warfare, horses were far more numerous than the tanks and other mechanical weapons of the Third Reich.

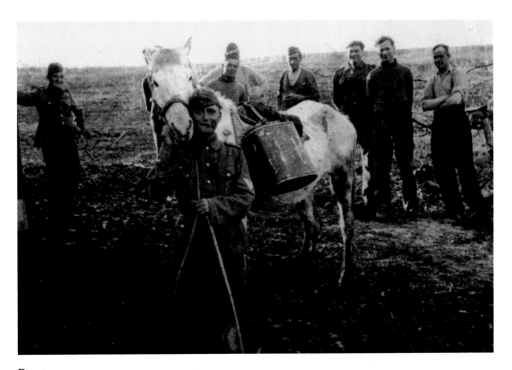

Roots
Many German soldiers had strong ties to the rich farmlands of Germany, where animals were an integral part of their lives. Horses especially enjoyed a special bond of 'blood and soil' with them. Here a young corporal poses with his equine friend, a food canister strapped over its back.

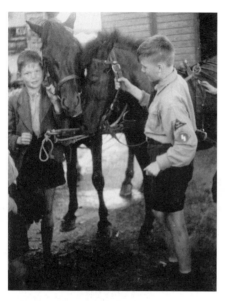

Brothers-in-Arms
Hitler Youth members, identified by the single lightning bolt insignia, visit with a team of Army horses. As future soldiers of the Third Reich, the boys took part in equestrian training via the various *Hitler Jugend* activities, the SS always eager to prepare more riders for its cavalry units.

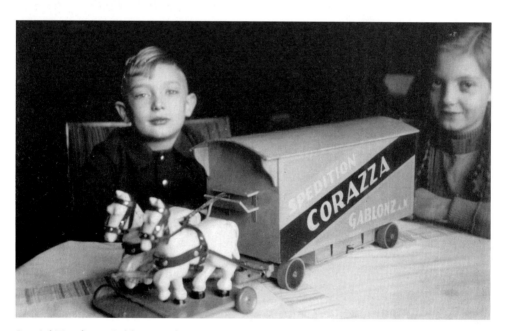

Special Toy from Gablonz – Christmas 1943
A young German boy and girl are photographed with a new toy, likely a Christmas gift. The wagon bears the words '*Corazza Spedition Gablonz*', which translates to 'Corazza Freight Transport of Gablonz'. Gablonz is a city in Northern Bohemia/Czechoslovakia, known for centuries as a centre for glassware manufacture and famous for its beautiful and intricate Christmas tree decorations. In March 1938, Britain and France, seeking to avoid war, acquiesced to Hitler's demands for the return of the area known as the Sudetenland, with its large population of German-speaking residents. Seven years later, and in the wake of the defeat of Nazi Germany and the arrival of Soviet forces, the Sudetenland *Volksdeutsche* were forcibly expelled by the Czechs during the summer of 1945, including those living in Gablonz.

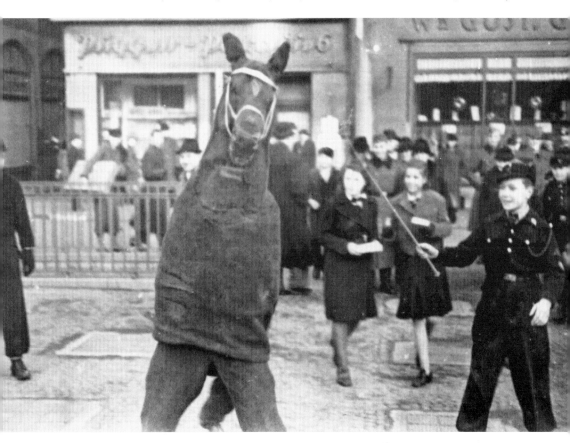

Make Believe

Hitler Youth boys in their black winter uniforms provide roadside entertainment for shoppers, the audience including BDM (Bund Deutscher Mädel) girls. By 1939, the year of Germany's invasion of Poland and the outbreak of the war, over 7 million (or nearly 82 per cent) of eligible German youths had joined the Hitler Youth. Further decrees made it mandatory, under penalty, for the remaining hold-outs to don the uniform. Evidence of the intensity of the indoctrination program can be seen in use of some 200,000 special trains required to transport 5 million German youths to the 12,000 HJ camps during the reign of the Third Reich. An estimated 1.5 million Hitler Youth boys received military training, including in the use of the rifle. 50,000 boys would earn the marksmanship medal indicating their proficiency at accurate firing to a distance of 50 meters (164 feet). Allied troops liberating some concentration camps found HJ (Hitler Jugend - Hitler Youth) boys executing prisoners. In the last weeks of the war, boys as young as ten would be sent against the Russian and American forces, some riding bicycles mounted with machineguns. Thousands of the surviving Nazi-indoctrinated youths would join the German post-war population.

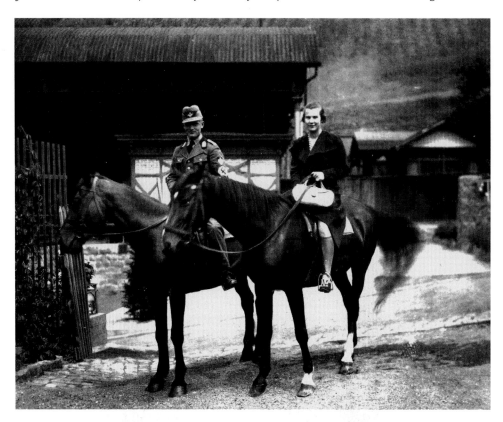

Courtship on Horseback

A member of the uniformed pre-military RAD pauses for a photo with his purse-carrying girlfriend. The Reichs Labor Service (*Reichsarbeitsdienst*), or RAD, a compulsory para-military organisation, was established by law in June 1934 whereby nineteen to twenty-five-year-olds, male and female, were required to work in the fields with farmers or perform other labour for a period of six months within a strictly disciplined program. During this time they drilled as soldiers, but instead of wielding rifles, they carried spades. With the introduction of the RAD program, Hitler solved the country's massive unemployment problem, provided cheap labour and indoctrinated the young. It also served to sidestep the restrictions of the post-First World War Treaty of Versailles that sought to limit German military expansion and provided a means to transition German youth into a military mold for later incorporation into the various branches of the Wehrmacht. RAD recruits entered a regimine that emphasised 'classlessness', with all members ostensibly graded on performance rather than socio-economic status or level of education, while strict adherence to the rules and submersion of self into the *uberkorpf* of the Third Reich was demanded en masse. Along with an emphasis on physical conditioning and political instruction, RAD boys were introduced to horsemanship, motorcycles, marksmanship, map reading, boxing and other martial skills.

By 1936, some 2 million girls were divided between the *Jungmädel* (ages ten to fourteen) and the *Bund Deutscher Mädel* (League of German Girls, comprised of those aged fifteen and older). Some 125,000 BDM leaders saw to their training at thirty-five area schools. As part of their national labour service, the young girls of the BDM were required to work as helpers for the wives of farmers; however, in practice the rapport between the city dwellers and the rural inhabitants was often lacking. The farmers accused them of being lazy or sexually promiscuous with soldiers, while the latter considered their rural overseers as abusive and exploitative. Both points of conjecture were often valid.

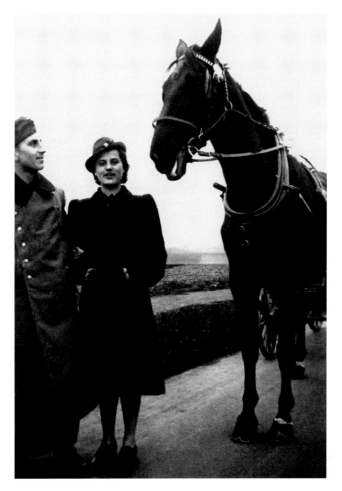

Beast of Burden

A large draught horse strapped into his collar and traces towers over a soldier and his lady friend. Hitler and the Nazi Party viewed women as helpmates to their men, producers of children for the Third Reich and homemakers, rearing their offspring in the NSDAP traditions. Third Reich social engineers sought to produce the superior German woman/breeder via the *Glaube und Schonheit,* or Faith and Beauty Program, which sought the most attractive girls of above-average intelligence. These women were instructed in gymnastics, horseback riding, pistol shooting, fencing and also automobile driving. The concept was one composed by chief Third Reich architect Albert Speer, Youth Leader Baldur von Schirach and film maker Leni Riefenstahl – three of the Third Reich's 'beautiful people'.

Many young German girls and women literally fell under Hitler's spell, overcome with an ecstatic devotion of fanatical intensity. Also possessed of a particularly virulent hatred of Jews, the German mothers passed this trait onto their daughters, who in turn responded fervently to the anti-semitic rhetoric of the BDM indocrination. While regarded as non-combatants to be shielded from the harshness of war, a number volunteered as *SS-Helferinnen* (SS Female Helpers). Some took their training at the women's concentration camp at Ravensbruck, where they observed the cruel actions of the male guards upon the prisoners and often took part in promiscuous sex with the guards, along with full participation in the severe military-style routine – all of which was designed to separate them from conventional morality and codes of conduct and enabled them to often outstrip their male counterparts in violence and cruelty.

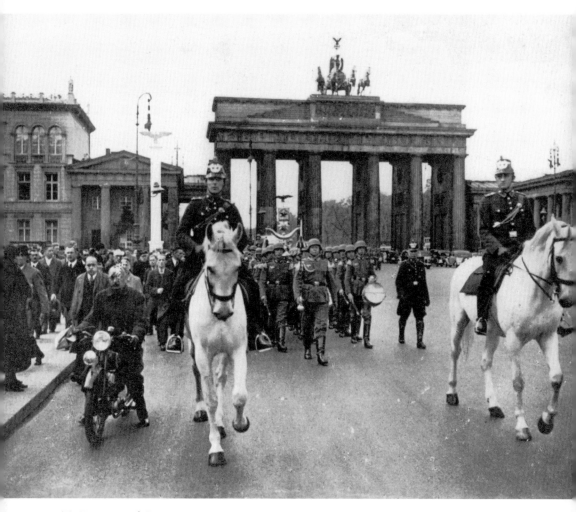

To Protect and Serve

As if echoing the *Quadriga of Victory* chariot sculpture surmounting the famed Brandenburg Gate, a pair of white police-mounted horses shares the Berlin boulevard with a motorcyclist and a military band. The two civilian policemen still wear the traditional *tschako (shako)* helmets, which were later replaced by the *Stahlhelm* – the iconic steel helmet worn by the military after the police forces were transferred into military service.

When first installed in 1793, the Brandenburg Gate included an olive branch representing peace, but was replaced with an Iron Cross after 1814. The insignia was then removed post-war by Soviet East Germany, and was then replaced again after German reunification in 1990.

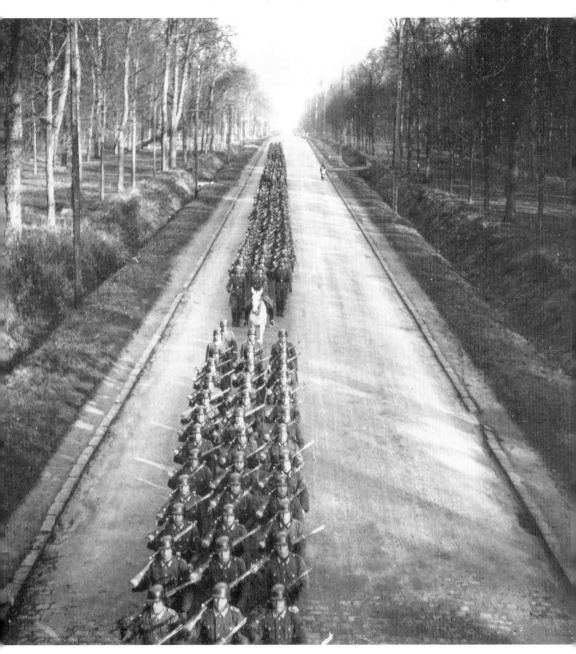

Punctuation Point
Only 25 per cent of the Germany Army was mechanised while 75 per cent was composed of marching infantry, the *Landser*, or foot soldier, slogging hundreds of miles across Europe in their hobnail boots.

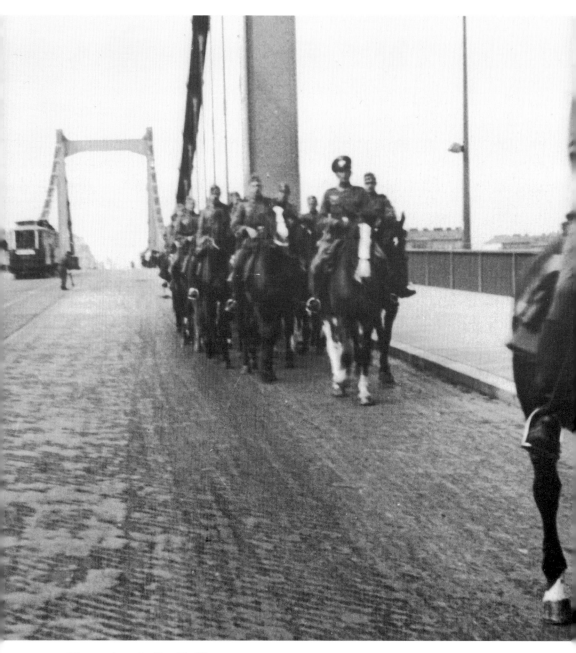

Vienna, Austria City Traffic

A cavalry troop crosses the *Reichsbrucke* in 1938. Another photographer is visible in the left background, near the trolleybus, as he adjusts his camera's tripod.

 While an independent nation, Austria had strong ethnic ties to Germany, and was absorbed peacefully into the Greater Reich as a result of the *Anschluss* or 'union' taking place in March 1938, with the country being renamed *Ostmark*. Hitler himself was an Austrian, later becoming a German citizen. However, he regarded Vienna with negative feelings as its art institute had refused his admittance. He considered Linz his 'home town', having lived there until 1907, and as a result planned a grandiose rebuilding of the city as the cultural centre of the Third Reich.

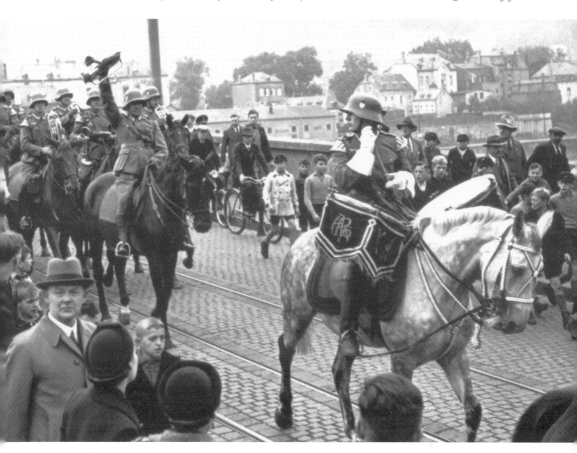

Pride of the Parade

In a government-issued photograph, mounted band members mesmerise both young and old. The band leader appears to have raised his trumpet, signalling a halt – the command noted by the young soldier in charge of the horse-mounted kettle drums. He is fortunate to be riding one of the famous *Trakehner* pure-breds. The soldiers wear a mix of helmets, including M18 early style helmets and newer versions showing national emblems, indicating a possible pre-war scene. One spectator, wearing a traditional Homburg, has noticed the photographer and stares directly into the camera.

Third Reich social engineers emphasised an incessant flow of spectacles, parades and martial music hammering the Third Reich 'sound track', which was intended to inundate the public's senses, often including the drumming of massed jackboots as well as horseshoes on the cobblestone streets.

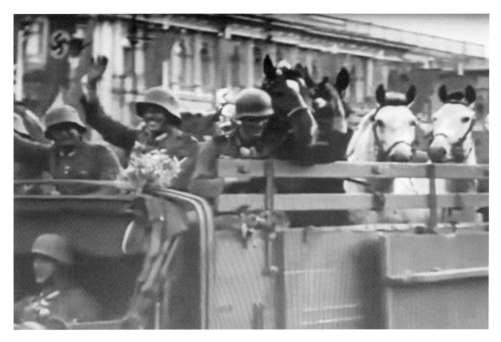

Truckload of War Horses
During the 18 June 1940 Berlin victory parade celebrating the German Wehrmacht's victory over Poland and France, several riders and their horses, veterans of the campaigns, receive a hero's welcome. The image was captured from an original German newsreel of the day.

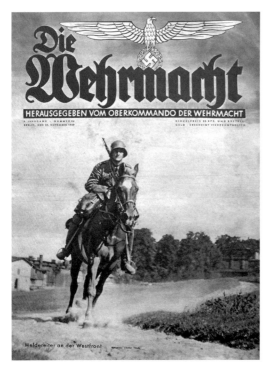

Messenger Rider on the Western Front
A vivid action shot is featured on the cover of *Die Wehrmacht*, the official magazine of the German High Command. The horseman wears a carry-over First World War-era M18 style helmet and had a Mauser K98 carbine slung over his right shoulder. Such horsemen relied on twenty-five hand signals to communicate with one another while in motion.

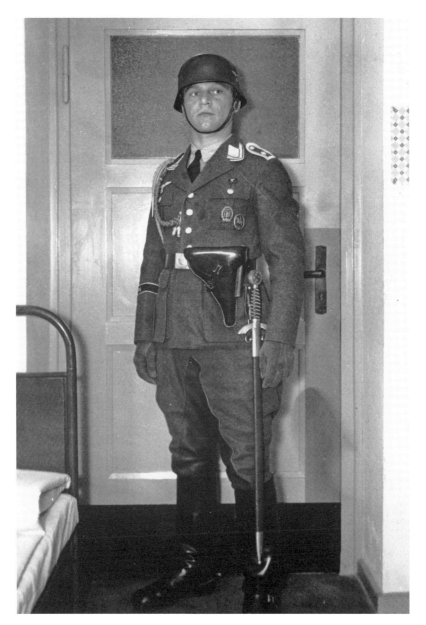

Sword and Spurs

Poising in his barracks room, a *Luftwaffe Obergefreiter* appears in full dress uniform, including a holstered 9 mm Luger, a ceremonial sword, leather gloves and a shoulder lanyard, as well as his steel helmet. He also wears the SA Sports Badge and the rare Horsemanship award originally intended for the Army.

Based on the 1930 introduction by the German Warmblood Association of the Rider's Achievement Award, the *Das Reitabzeichen,* or Rider's Badge, required successful testing of riding theory, anatomy, and horsemastership. The German Army, the largest equestrian organisation in the country, administered the test and awarded the badges to both civilians and soldiers. *Rittmeister* (cavalry captains) and artillery captains (squadron or battery commanders) were authorised to conduct the testing.

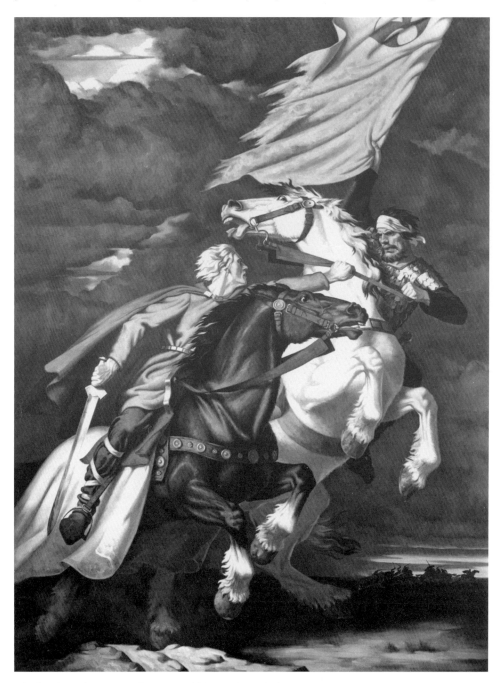

Clash of Percheron Warhorses and Teutonic Knights
Archetypical warhorses dominate Third Reich-approved Herbert Kampf's painting, entitled 'Um die Fahne' (Around the Flag), which is displayed in the Munich House of German Art. Recognised for his wars of independence history themes (his own name translating to 'struggle or battle'), Kampf's work sold in large numbers as books, wall posters and postcards. Nazi state propagandists included his works in the 1939 'List of Immortals'. He and his art survived the war, with him dying in 1950 aged eighty-six.

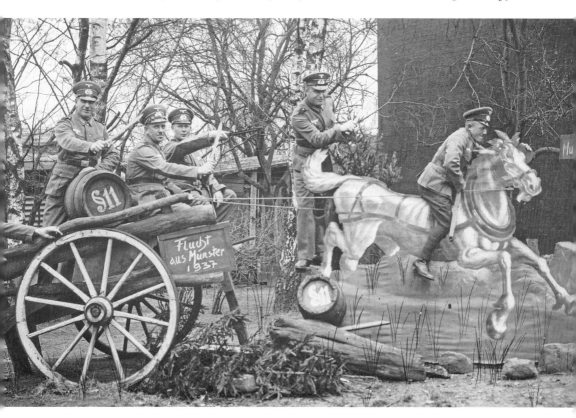

Escape from Munster 1937 – Bayonets Drawn
A comic photo has been staged at the Richard Schubert Photographic Studio near the Munster area Army camp. The small town located mid-way between Hamburg and Hanover first served as a military training area in 1893. During the First World War it was a centre for chemical weapons research and development, and was re-opened as such by the Wehrmacht in 1935, with 'fog' being the codename for the mustard gas and nerve gas produced there.

On 15 March 1937, Munster's new Nazi regional office was the scene of a cornerstone dedication ceremony. On the following 7 May, the German Condor Legion fighter aircraft and crew arrived in Spain in support of Franco's fascist regime during the country's civil war. In Germany, on 28 May, a new company was formed to produce the Volkswagen. On 5 November 1937, during a secret meeting at the Reich Chancellery, Hitler made known his plans for war by conquering lands to enlarge German 'living space' (*lebensraum*).

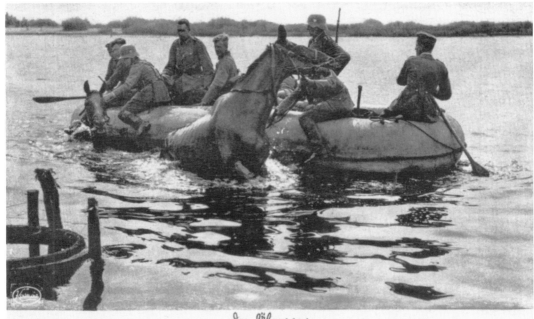

Der Übergang

River Crossing
Combat engineers (*Pionier*) practice river crossing by rubber raft, with two horses swimming alongside as cargo.

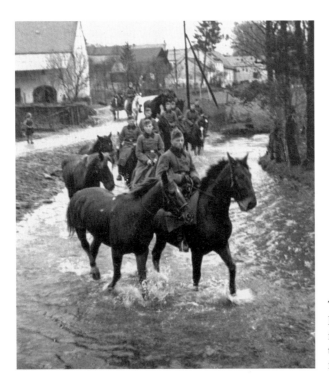

Taking the Plunge
Horses are taken into a stream to familiarise them with the experience that will transfer to the battlefield fording of water obstacles.

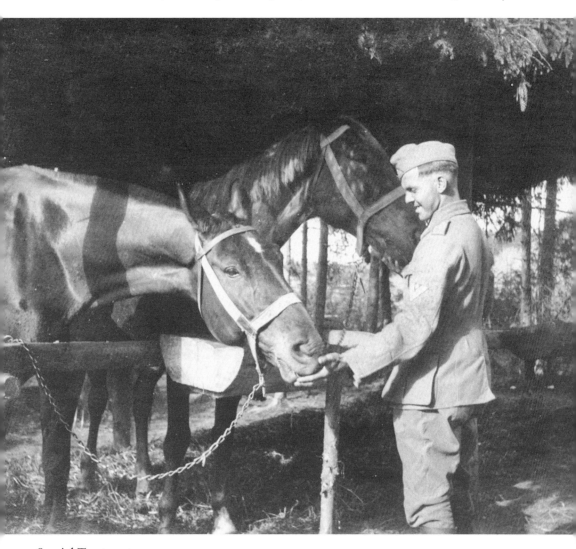

Special Treatment
A corporal has apparently brought something tasty for his friends, who are housed beneath a rough-hewn makeshift field stable.

Supplying food for the hundreds of thousands of horses employed by the German military was a daunting task, and eventually the quality and quantity fell dangerously below minimal standards. In addition, huge quantities of fodder had to be shipped by rail, competing with the critical delivery needs of war resources. Foraging off the land was often the end result, with the horses suffering as a result.

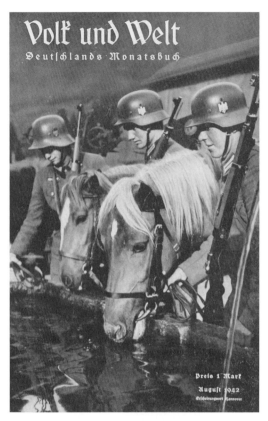

Volk und Welt – August 1942
Published monthly in softback book
form, the publication's title translates
to 'Folk and World'. This fifty-six-page
issue of the general-interest publication
contains articles concerning India,
Goethe's home in Frankfurt, the function
and form of light relative to photography,
essays on farming, mountain scenery,
fiction and poetry.

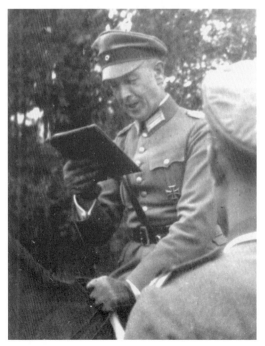

Identified Rider
Handwritten notations indicate the
photograph captures the image of a
Colonel Schroth, director of an infantry
school located in Dresden. The soft-style
caps indicate the early war period. The
Oberst wears the Iron Cross First Class,
most likely of First World War vintage.

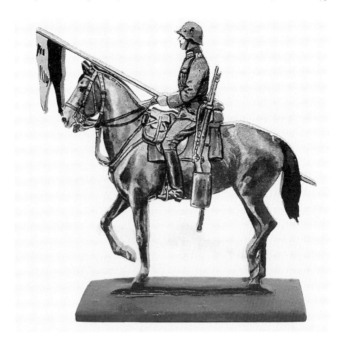

**Child's Toy of War –
1930–40s**
This cavalryman figure was crafted from a wood frame, onto which the paper image was then glued. He is shown wearing the special cavalry helmet with ear cut-outs and carrying a troop pennant. A Mauser carbine in a leather scabbard is within easy reach.

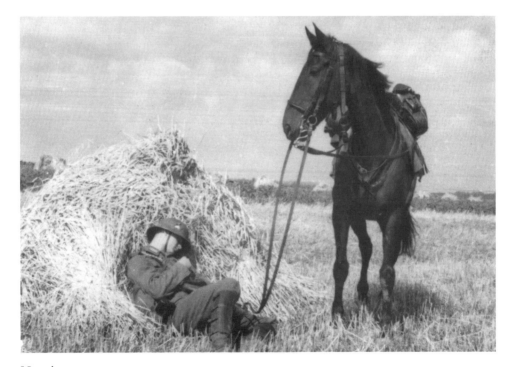

Napping
A solider has found a haystack to be too inviting. His horses stands patiently by while one of his comrades, who has chanced upon the scene, records the moment. This most likely occurred in pre-war times, as falling asleep while on guard duty in wartime could result in death by firing squad.

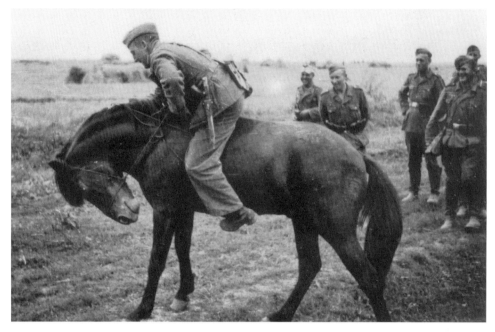

Buckin' Bronco
Somewhere in France an NCO tries his hand at riding bareback on an uncooperative horse, much to the amusement of his comrades.

Three-Footed
A rider takes an awkward position for the camera while the tell-tale cavalry spurs of his comrade also appear in the photo.

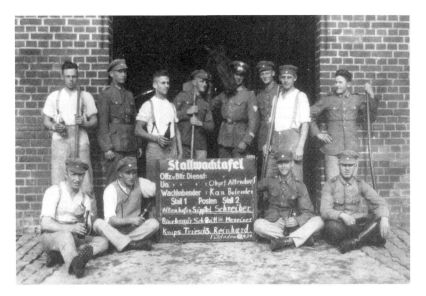

Stallwachtafel

Stationed in Leipzig, a team of soldiers, some holding bottles of beer, pose with one of their four-legged charges. The names of the 'stall watchers staff' appear on the chalkboard along with the date – 23 September 1934. The number of brooms indicate their labour-intensive responsibilities. Keeping the horse stalls meticulously clean and disinfected was essential for the prevention of glanders, a germ-borne disease that attacked, often fatally, a horse's respiratory system.

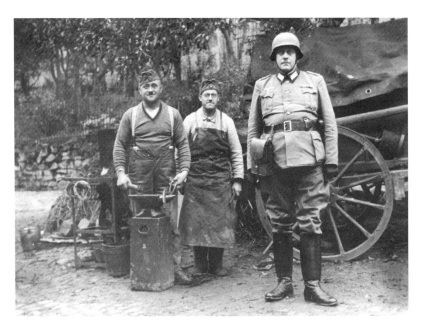

Der Schmiede

A stout veteran poses with a duo of blacksmiths in the midst of producing new horse shoes, which are being hammered on a portable anvil. They also often repaired the wooden wagon wheels and their outer metal rims, which required an unending maintenance effort.

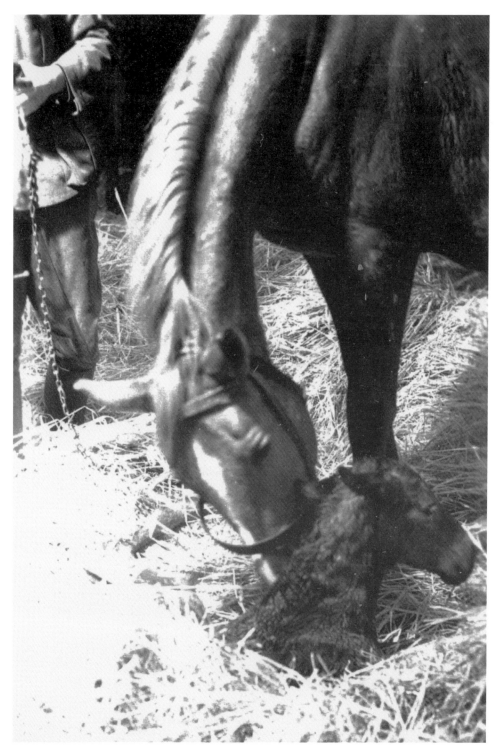

Just Born
As soldiers look on, a mare cleans her recently birthed colt, which is half buried in a bed of hay.

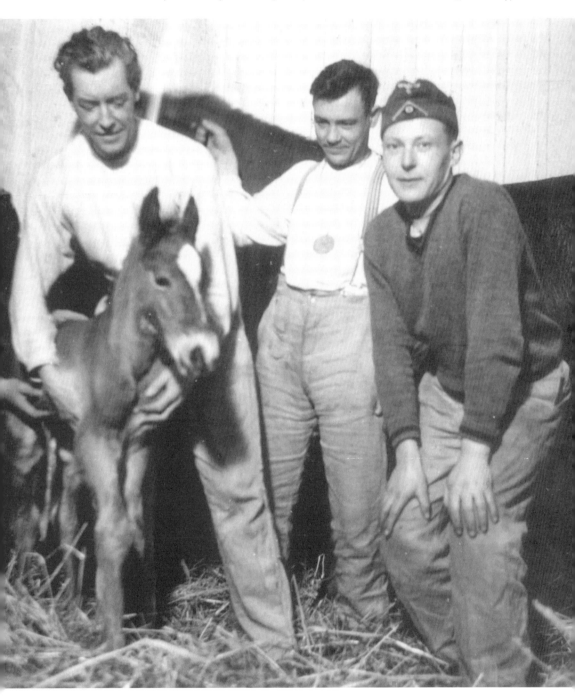

First Steps

A series of images documenting the birth of the colt shows it receiving a helping hand. The colt apparently wears the same 'white diamond' head markings as his mother, as seen in the previous photo. One soldier wears an overseas cap, indicating that the location is very likely France. The soldier in the centre wears his two-section 'dog tags' outside his shirt. One part would stay with a soldier's corpse, while the other was taken by the Graves Registration Unit.

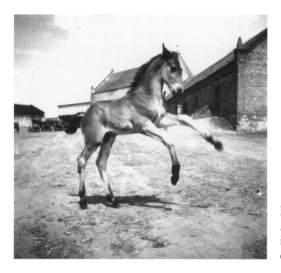

Kicking up its Heels
A soldier's camera captures another colt in high spirits, prancing near the stables of a large horse farm.

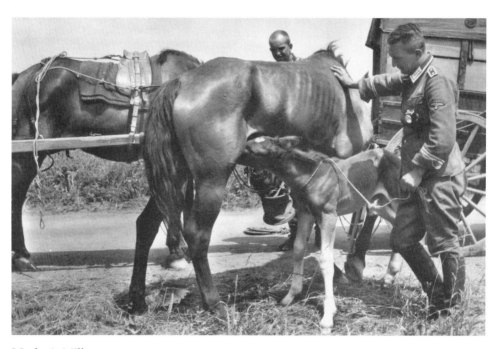

Mother's Milk
A *Waffen-SS* NCO, as identified by his sleeve insignia, sees to a newborn colt's meal as another SS man uses a standard feedbag for the harnessed wagon horse.

The SS, initially Hitler's eight-man personal bodyguard, grew into a vast empire unto itself, with its every move orchestrated by *Reichsführer-SS* Heinrich Himmler. As Hitler's ideological soldiers, the SS functioned as the implementers of mass murder on an industrial scale, literally as 'instruments of terror'. They envisioned themselves as the rightful masters of Europe, with all others as either their slaves or subject to annihilation. Responsible for internal security, intelligence gathering and operating the slave labour and death camps, the SS also formed fanatical combat divisions of the *Waffen-SS*, totalling some 900,000 strong and among the last to defend Berlin even after Hitler had committed suicide.

Right: **Knowing Hands**
A veterinarian administers to one of
his patients at a horse training centre.
The German cavalry maintained
a medical support system of some
13,000, including 5,650 veterinarians
and 700 doctors.

Below: **Dr Schmidt and
Wild-Eyed Patient**
With the aid of his assistants, the
veterinarian performs an operation
on a horse's lip at a training facility
located in Leisnig, near Hanover. Each
infantry division also maintained
its own horse hospital while
examination stations were set up for
horses conscripted from the field of
conquest. For example, Poland, once
defeated, provided a mainstay of
German Army horse supply, although
policy took care not to overtax the
supply of horses needed by the Polish
agricultural system as it provided
a much-needed food source for the
German military, often at the expense
of the civilian population.

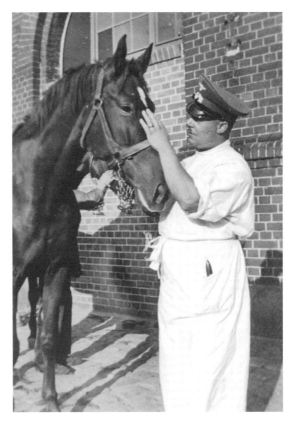

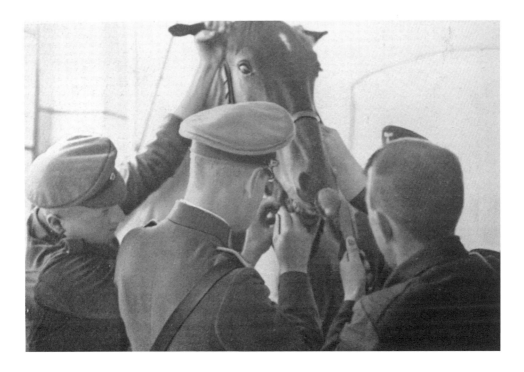

Jesus! Maria! Josef!

Ach es ist ja kaum zu fassen,
Daß du nicht mehr kehrst zurück.
So jung mußt'st du dein Leben lassen,
Zerstört ist unser ganzes Glück.

Geliebt und betrauert von allen, die ihn
kannten, bleibt sein Andenken in Ehren.

Zur frommen Erinnerung
an meinen innigstgeliebten Gatten
unsern lieben Sohn, Bruder, Schwieger-
sohn, Schwager und Onkel

Franz Greuel

Obergefreiter in einer Veterinär-Komp.

Er wurde geboren am 15. Januar 1908
zu Luxheim, Kr. Düren. Seit 2³/₄ Jahren
war er Soldat in Frankreich und im
Osten, im Raum Rschew fiel er am
14. Dezember 1942. Er gab das Leben
hin gemäß der Schrift: Auch wir müs-
sen das Leben lassen für unsere Brüder.

In tiefer Trauer:
Frau Maria Greuel, geb. Donsbach
Familie Josel Greuel
Familie Michael Donsbach
und die übrigen Anverwandten.

Gelsenkirchen, Lüxheim und im Felde,
im Februar 1943.

KIA Veterinarian

The traditional memorial card or *Sterbebild* (deathcard) pays homage to Franz Greuel, a corporal in a Veterinarian company. Details of his brief biography include his two years and nine months of military service, spanning the campaigns in France and the Soviet Union. He was killed on 14 December 1942 during defensive engagements with Russian forces. A portion reads, 'He gave his life according to the Scriptures: We must also give our lives for our brothers.' By October 1941 the German Army counted some 24,000 veterinary troops, who were deployed in the Soviet Union – an indication of the vast number of horses employed on the Eastern Front.

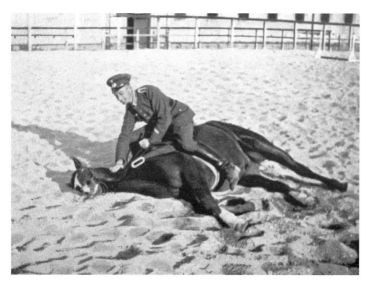

In Training
A horse trainer is apparently pleased with his student's performance. Horses were trained to 'take cover' like their riders, as well as to provide cover for them.

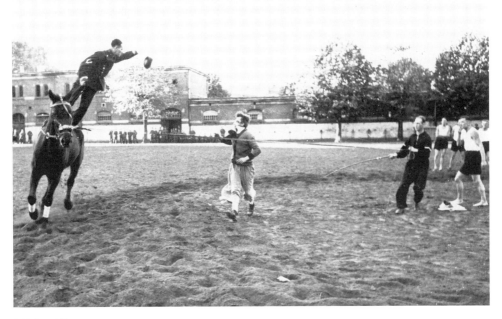

Trick Riding
At a cavalry training centre, a horseman practices a hat-catching stunt as his comrades observe the action.

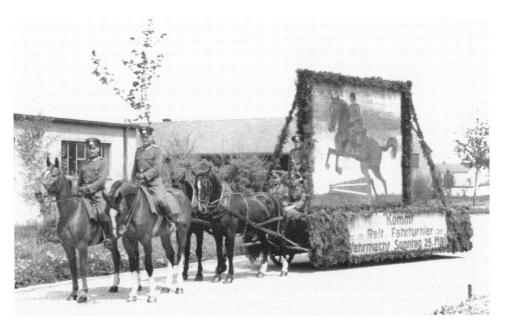

Horse-Drawn Float
Led by two NCOs, a quartet of splendid thoroughbred horses pull a float announcing an upcoming horsemanship demonstration on Sunday 25 May. Such public relation events were frequently promoted by the Wehrmacht.

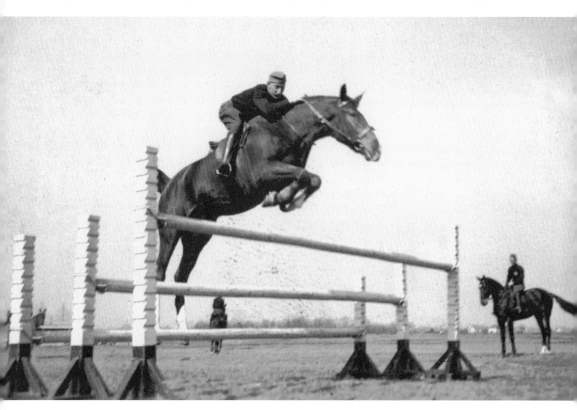

SS High Jump Mid-Way
At the *SS-Hauptreitschule München*, an SS cavalry training school located in Munich, horse and rider take to the air while scaling a triple-threat barricade. Formed in 1942, the SS Cavalry Division *Florian Geyer* was named for the sixteenth-century Franconian knight who led a heavy cavalry detachment during the Peasants' War on the side of the peasants. While later touted by Marxists as a communist hero, he was also regarded as an early Teutonic hero by the Third Reich, thus the choice of name for the cavalry division. The *Florian Geyer* division, of which there were initially some 15,000 men, was virtually annihilated by Soviet troops during the November 1944 to February 1945 battle of Budapest – the dead including its commanding officer, *Brigadeführer* Joachim Rumohr of the division's 8th Unit.

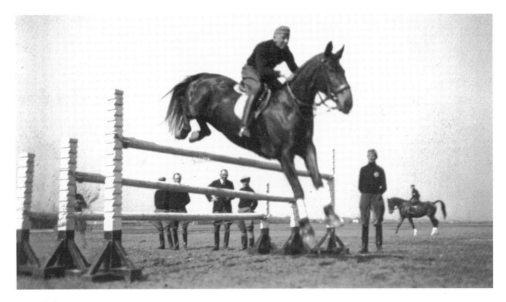

Touchdown
Successfully clearing the obstacle, horse and rider prepare for their landing. Also taking part in the Hungarian conflagration was the 22nd SS *Freiwilligen-Kavallerie* Division *Maria Theresia*. The unit, previously named SS Division *Ungarn*, was formed around a nucleus of German officers but was composed primarily of Hungarian *Volksdeutsche* volunteers. The symbol of the *Maria Theresia* division was the cornflower, which was the favourite flower of another German hero, Empress Maria Theresa from the House of Habsburg, a dynasty that ruled Austria, Hungary and Bohemia in the eighteenth century.

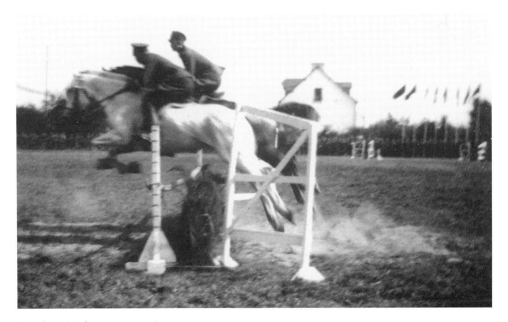

Synchronised Demonstration
A pair of cavalrymen takes part in a public exhibition; large crowds are visible in the background.

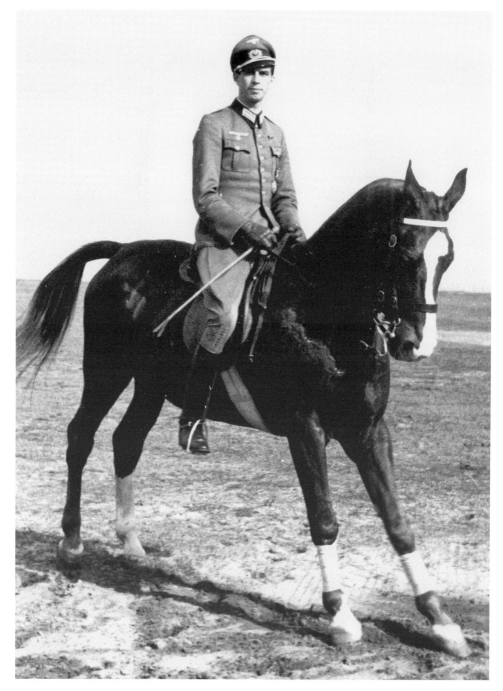

Rider Identified

Handwritten notes on the back of this photo identify the horseman as a Major Jürgen Riekel, the photograph having been snapped in May 1944 in ill-fated Dresden. The famous cultural city would soon suffer a catastrophic and still controversial Allied firebombing in February 1945, which would kill between 35,000 and 100,000 civilians. While many point out its status as a civilian refugee centre rather than a military target, others point to the railyards as a viable war target.

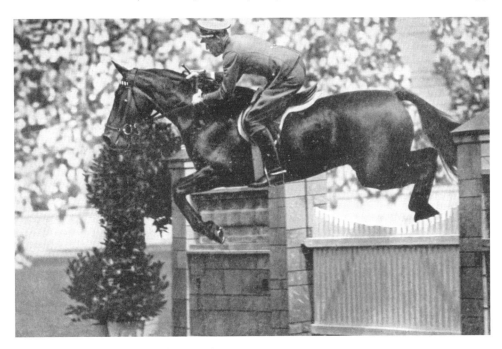

Champion Form – 1936 Berlin XI Olympics

Already the winner of the 1935 Internal Military award in the Dobertiz competitions, Captain Ludwig Stubbendorff and his exceptional Pelargonie mount, Nurmi, are seen leaping to more honours. The pair would earn two gold medals for Germany in both individual and team events, including the exceptionally difficult and often dangerous Men's Three-Day competition combining dressage, cross-country and jumping.

An estimated 100,000 spectators crowded the Berlin arena to watch the competing international teams, which included France, Canada, Brazil, the Philippine Islands, Bermuda, Greece, the USA, Hungary, Great Britain, Denmark, Austria, Luxemburg, Poland, Japan, Germany, Sweden, Egypt and Yugoslavia.

While Stubbendorff and Nurmi won the crowning event for the German team, other riders and their horses taking part in the three-day event met disaster. Three horses died as the result of injuries, including the Hungarian entry, Legeny, who was ridden by Lt Stefan Visy, the horse stumbling without apparent reason on flat ground during a cross-country ride. Then, during a steeplechase event, the Swedish entry, Monaster, a famous thoroughbred ridden by Lt Nyblaeus, injured both front legs and had to be put down. Thirdly, the American horse, Slippery Slim, considered to be one of the most beautiful horses in the competition, suffered major injuries when landing badly in a pond obstacle and also had to be euthanised. The three deaths put the three teams out of the competition. Only four teams reached the successful completion of the series of cross-country, steeplechase and dressage. The four included Great Britain (who won third place in the Team Competition), Czechoslovakia, Poland and Germany. One Polish competitor broke several ribs in a fall but persevered, ultimately winning a silver medal, while a German rider broke his collarbone after being thrown but remained in the competition, helping his team complete the events.

Stubbendorff's exceptional horse was named in honour of the famous Finnish runner and multi-Olympic medal winner Paavo Nurmi, who attended the 1936 event to support the eponymous horse. Despite his achievements, Stubbendorff would be sent off to lead troops on the Russian Front. Three years later, Captain Stubbendorff was killed in action on 17 August 1941 in Nikonovichi, Mahilyow, Belarus, during the second month of the invasion of the Soviet Union. Subsequently, German one-day events were called Stubbendorff Trials in his honour.

Wearing Silks – January 1940
As an adjunct of honing battlefield skills, horse racing was encouraged by the Wehrmacht, with the resulting jockeys wearing a variety of thirty-eight different racing colours representing the various battalions and regiments. In addition, some horse-mounted and horse-drawn units augmented their training by participating in fox hunts.

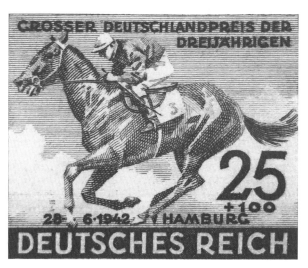

Special Issue Postal Stamp: Greater Germany Prize for Three-Year-Olds, Hamburg – 28 June 1942 (Second Invasion of Russia)
On the very day of the annual race held in Hamburg, Hitler lauched '*Fall Blau*'(Case Blue), the codename for a new attack on Russia, with the second summer assault following the initial invasion of Sunday, 22 June 1941. The new offensive targeted the Caucasus oil fields at Baku, both to cut off fuel supplies for the Red Army and to provide the much-needed commodity for German forces now stretched thin across the Soviet Union. As in the first assault, it was hoped that the second blitzkrieg would bring Russia to its knees. Initial successes were rapid and suceeded in acquiring several oil fields, but the German 6th Army's disastrous defeat at Stalingrad and subsequent Russian counter-offensives sent German forces reeling in a never-ending retreat termed 'strategic withdrawal'.

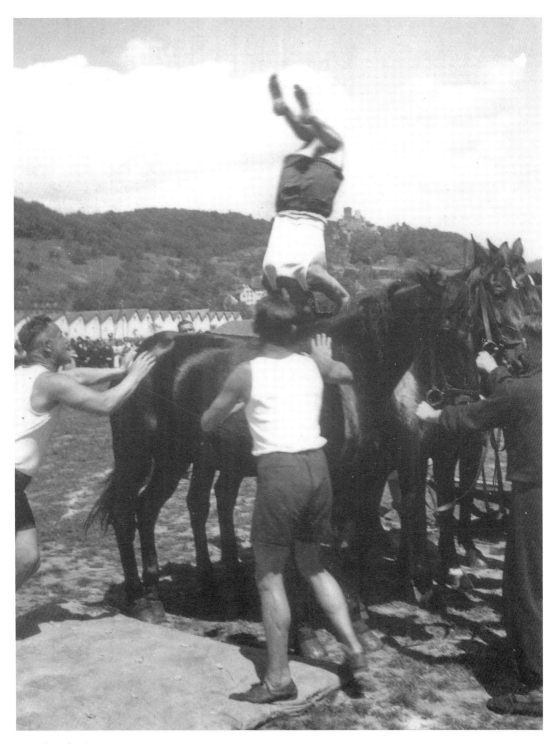

Acrobatics
In a photograph dated 1936, German equestrians take part in a public demonstration during the
Berlin Olympics. Large crowds, as well as extensive horse barns, are visible in the background.

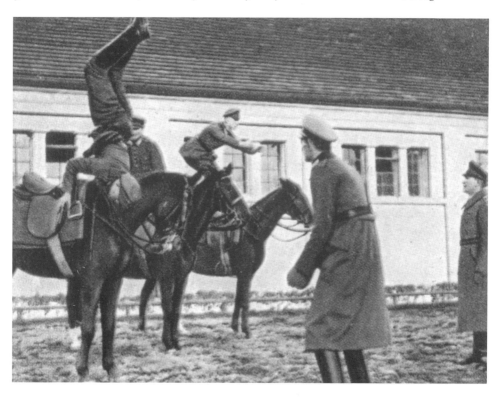

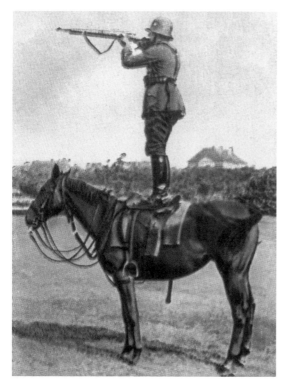

Above**: Voltigieren – **Vaulting

This is Illustration No. 47 from a series of 210 colourised collector cards as found in packets of Jasmatzi Ramses cigarettes. This example carried captioning on the reverse that translates as: 'For vaulting exercises, man and horse are teamed together. The animal learns to keep still while the recruit loses his initial anxiety.' What appear to be showy dramatics are actually combat training drills when fast mounts and dismounts under fire could mean life or death.

***Left**: Schwieriger Schus –*
Difficult Shot

No. 69 from the same series of cigarette cards carries the notation: 'Although it is unlikely to occur, in an emergency case, a rifleman can fire from standing in the saddle. However the practice value is very high. It demonstrates the perfect obedience of the horse and the rider's excellent training.'

Equine Excellence

Some of the finest breeds were recruited, including the German warmblood Hanoverian and Trakehner, which is seen here, as well as the Romanian Furioso. Of all Axis allies, the Romanians supplied the largest contingent of cavalry forces.

The Trakehner horse held a special place in the hierarchy of German equine history as it was recognised as the national horse of the Prussian-German Empire. Bred in the Prussian town of its name, strict guidelines were originally established by King Friedrich Wilhelm I of Prussia. The development of the breed involved local Schwaike horses being bred with Polish-Arabians supplied by the King of Poland and later with thoroughbreds imported from England. Here the Second World War intervened, bringing the breed to near extinction. Many were killed during the Soviet drive into Nazi Germany and then, post-war, along with the German population being violently forced from previously occupied areas, so too were the Trakehner. However, examples of the top studs and mares survived the evacuation to West Germany. Additional horses were saved by the von Brandt-Rosenthal family, who under Nazi persecution had fled to Switzerland, but then returned to Germany post-war to help revive the original Trakehner breed.

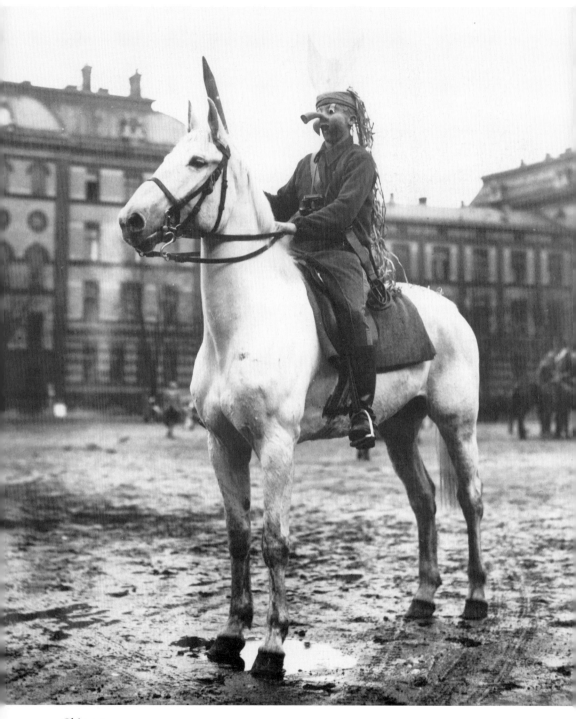

Chimera
A splendid white stallion carries a soldier in a ghoulish costume, perhaps during the annual *Fasching* or *Fastnack* holiday celebrations, the pre-Lenten festivities celebrated in Germany's Catholic regions.

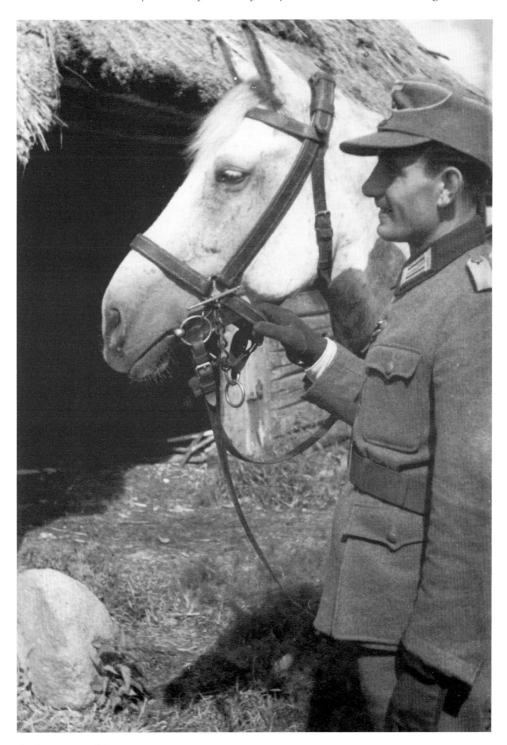

A Horse named Lotte
A soldier poses for a farewell photo with his horse on the Eastern Front. The notation on the photograph indicated the soldier was returning home while the horse remained on duty.

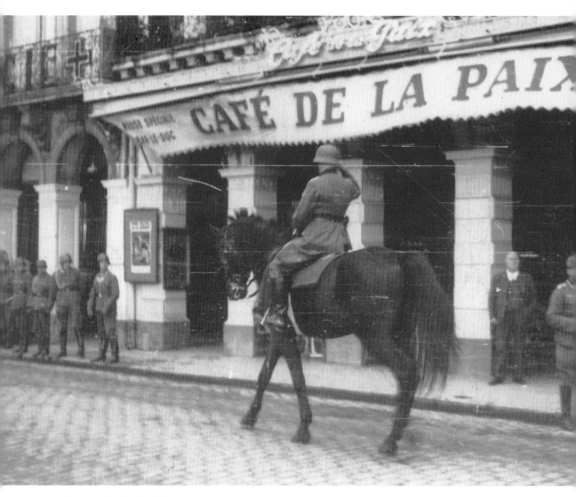

Contradiction in Terms

A German cameraman, perhaps aware of the ironic composition, has captured the image of a horse-mounted soldier in Paris passing in front of the famous *Café de la Paix* (Café of Peace), located in the *Place de l'Opéra*. The French had capitulated after six weeks of fighting in the summer of 1940, the speed of the victory even surprising the Wehrmacht. French casualties totalled 85,000; German 27,000. After the war ended the Café served as sanctuary for thousands of displaced persons.

Occupied France, which served as a source of slave labour and a 'quiet non-combat' area to refresh and rebuild German military forces, would supply the Third Reich with over 150,000 horses by late February 1942, as well as tons of fodder.

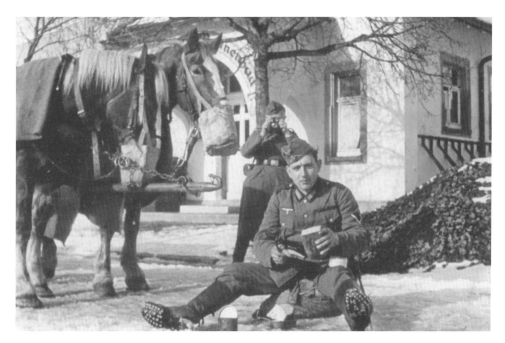

Mirror Image Meal Time

Horses and horseman are being fed. Feedbags for the hoofed, a loaf of bread for the hobnailed soldier being photographed, while in the background another cameraman snaps a photo of the unseen photographer. Due to the stresses on man and material caused by combat conditions, shortages of all types afflicted the warhorses, especially in Russia. Sometimes tree bark was added to their fodder and there was even a shortage of cotton feedbags, which were susceptible to rapid deterioration. As a stop gap, wooden troughs for the group feeding of three horses was implemented, but this led to the spread of equine diseases. In addition there was even a shortage of bailing wire with which to bind bales of fodder, while another official dictate required that all horse manure was to be collected as fertiliser and transported back to Germany.

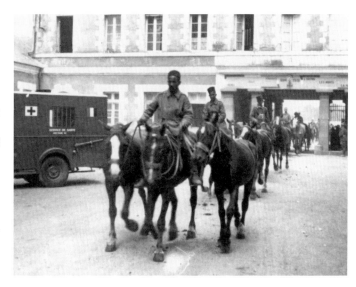

POW French Horses

As German soldiers look on in the background to the right, French African Colonial soldiers ride out on horseback through an archway commemorating the veterans of the First World War. France had relied on tens of thousands of West and North African 'recruits' to fight in their European wars, while denying them the rights of their white countrymen.

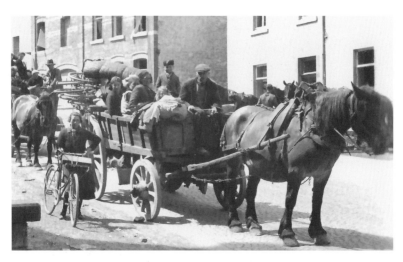

In Flight
Horses and bicycles served as the prime modes of transport for civilians fleeing the onslaught of war. A French family has filled a large wooden-wheeled wagon with all their possessions, with a single, massive farm horse bearing the load and pausing long enough for a German soldier to take his souvenir photo. Refugees and their horses often clogged the roadways, impeding both German and Allied troop movements, and as a result often became the victims of 'collateral damage'.

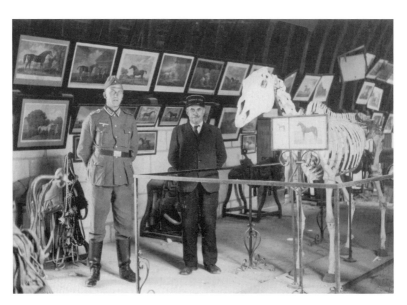

Common Interest – France Occupied
With its chief custodian standing by, a soldier visits a French horse museum. Famous thoroughbreds are immortalised in paintings hanging on the wall while tackle, saddles and a complete horse skeleton are also visible. France's most famous homage to the horse, the Living Museum of the Horse, was built around the 200-year-old Great Stables of the Château de Chantilly, located some 40 km north of Paris. Its collection includes thirty-one living breeds as well as 1,200 items relating to the horse's history in art and horsemanship. Open to the public and privately operated, it currently receives some 200,000 visitors annually.

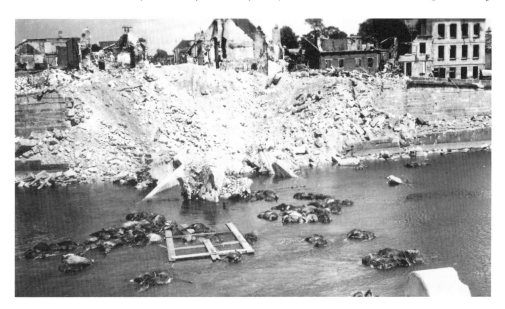

Mass Carnage
Massive explosions have destroyed a French bridge, catching several horse teams midway in their attempted crossing. Their bodies, many still hitched to their traces, clog the water, bloated in death.

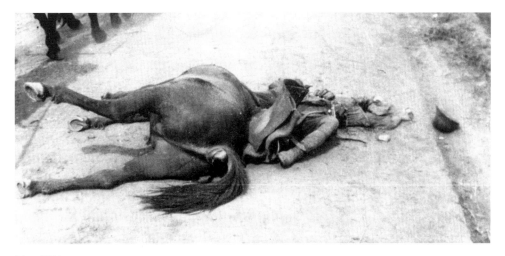

Two KIA
A cavalry trooper and his mount lie sprawled in death across a French roadway as German wagons roll by. The soldier appears to be an African Colonial solider – one of thousands that will die defending France, far from their own homes.

Of the ninety-four French divisions facing the German onslaught of May 1940, eight were composed of colonial infantry, who suffered the loss of a quarter of their soldiers and were considered by many as the most heroic of all those who fought for France. The precise number of French African colonial conscripts who died as combatants in the war is unknown but at least 10,000 died, with thousands more designated missing in action. It is known that German troops, spurred on by Nazi propaganda and the ferocity of close combat, sometimes executed the wounded Africans and took part in the mass shootings of those who had been captured.

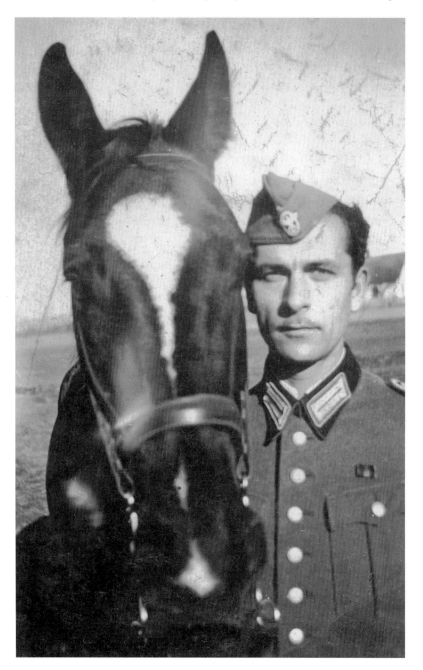

Police Horse
A member of the German police, perhaps the 5th Police Calvary Battalion, poses with his riding mount. Notations on the reverse of the photo indicate it was taken sometime in 1941 in Jaslo, a rural city located in south-eastern Poland. Nearby was the Szebnie concentration camp where many of Jaslo's Jews were exterminated, the killings lasting until 1943. Mobile German police units, operating in Eastern Europe and Russia, were instrumental in the shooting of over 1 million Jewish men, women and children during the 'Holocaust by Bullets' prior to the establishment of the Extermination Centres.

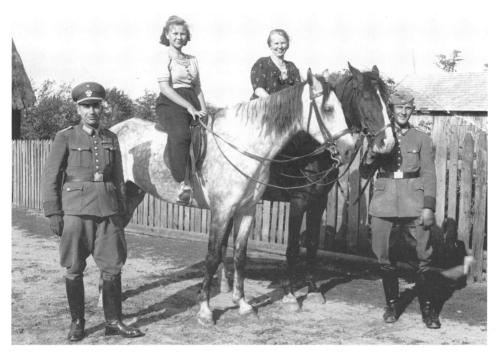

Riding Companions
Two polizei share the photo with female friends, who are astride the policemen's mounts. The lighter colored animal is a prized Trakehner. On occasion, wives and girlfriends were invited to make the train trip from Germany to Eastern Europe to watch the men at work during mass executions.

Man vs. Horse
During Day of the Police celebrations, competitors on foot and horseback engage in some form of a relay rally. The mounted policeman holds a ring, which is apparently to be passed along. A motorcyclist is visible in the background, possibly also as part of the event.

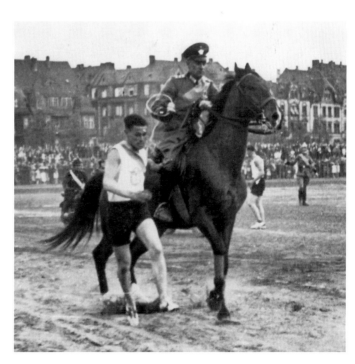

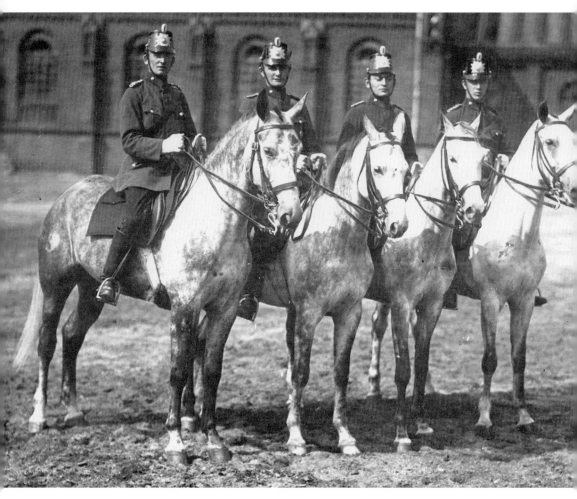

Mounted *Tshako*-Helmeted Police – Breslau, Germany

This photo-postcard, postmarked 13 September 1930 and addressed to a Paul Vogl, was produced at the Paul Weich photograph workshop. Specialists in photographing horse riding, racing events and carriage driving, the studio was locted near the Breslau Barracks. The quartet of horses appear to be Trakehner.

Breslau, situated in the Silesian Lowlands on the River Oder, had found itself over the years of political and military unrest under various flags, including those of Poland, Bohemia, Hungary, the Austrian Empire and Germany, whereupon it became the largest city east of Berlin during the Nazi era. While it was historically considered a liberal left-wing bastion, it became strongly pro-Nazi, with attacks being mounted against Polish institutions including assaults by local police against the city's Polish culture center, with several concentration and slave labour camps later being established in its vicinity.

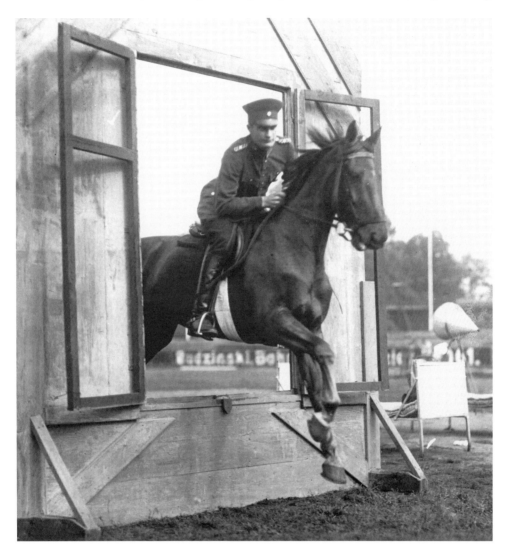

Window Escape

A policeman takes his mount through a Breslau training course sometime in 1930. Notice the conical loudspeaker on its stand in the background.

Anti-Semitic riots broke out in Breslau during 1923 as the Nazi movement spread. In late 1938, Jewish synagogues, schools and cemeteries were destroyed, all cultural activities banned. Deportations began in 1941, the trains taking the condemned to Auschwitz, Treblinka, Sobibor and other death camps. Most of the city's 10,000 Jewish residents perished.

The 'postcard' city was spared Allied bombing until it was declared a *Festung*, or Fortress City, by Hitler in the last months of the war. The encirclement by Soviet forces resulted in a savage eighty-day siege (13 February to 26 May 1945) that destroyed most of the city, resulting in some 70,000 Soviet military casualties and at least 40,000 German military and civilian casualties. The city's defenders were a mix of Hitler Youth, First World War veterans, regular troops and police. SS execution squads roamed the city, summarily killing those guilty of being 'pessimists or looters', including the city's deputy mayor. Additionally, some 18,000 civilians froze to death during a hasty evacuation. Post-war Breslau became part of Poland and was renamed Wrocław. It was declared the 2016 European Capital of Culture.

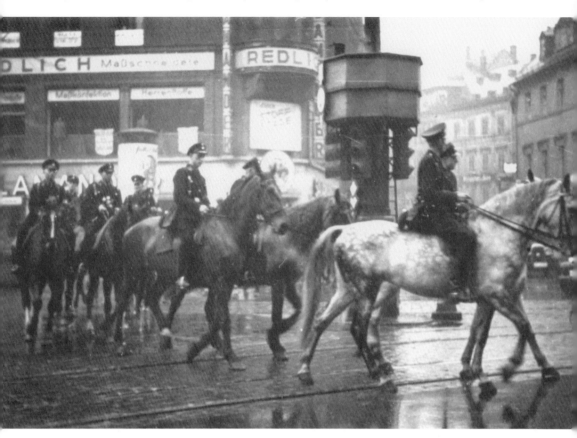

Police Horses on Parade

SS cavalry (*SS-Reiterei*) clatter through the cobblestone streets and over tram tracks in Berlin. In the background can be seen a department store catering to men's and women's fashions as well as a traffic control tower hung with a cluster of traffic signals and topped by an observation platform. The lead white and grey mottled horse appears to be a Trakehner.

During 1930–39, 200,000 members passed through the ranks of the horse-mounted SS, although many had no horses of their own. While Himmler strove to inculcate a classless structure, recruiting farmers and average Germans, many hailed from the aristocracy, the traditional members of the cavalry. SS riders competed vigorously and very successfully in national and international events, as did regular Army horsemen. The positive publicity served to advance the image of the SS, although the regular SS and 'old fighters' considered the horsemen an elitist group. SS riding academies were established in the cities of Forst, Munich and Hamburg and competed for both funding and recruits against the SA (Sturm Abteilung) and regular Army equestrian formations.

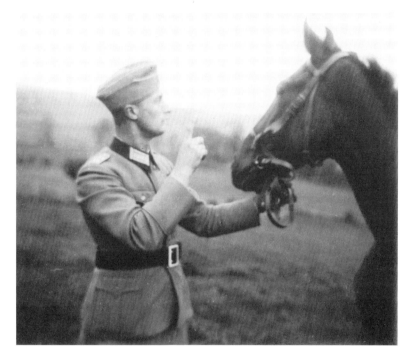

Taking Orders

An SS policeman apparently takes his horse to task over some issue.

After the outbreak of war, four special horse-mounted Death's Head police formations (3,500 men and 2,900 horses) were established for use in Poland by the SS (*Totenkopf-Reiterstandarten*). The SS Cavalry Brigades were an integral part of the Third Reich's racial war and training included intensive ideological instruction. Under Himmler's direction they became the first units to carry out orders to expand beyond male victims to murder Jewish women and children.

The so-called 'political soldiers' of the SS Cavalry Brigade, operating in the Russian Pripet Marshes during a period of two weeks, murdered 15,878 men, women and children, themselves experiencing only two casualties. SS cavalry also took part in the shooting of the entire Jewish population of Bobruisk, some 7,000 individuals, and another 7,819 in the area of Minsk. A second combing of the Pripet area recorded another 31,403 executed.

In mid-October 1944, the Germans learned that Hungary's ruler, Admiral Miklós Horthy, was negotiating a secret surrender to the Soviets. A German commando team, led by the legendary Otto Skorzeny, stormed Buda Castle and forced Horthy to abdicate, while also kidnapping Horthy's pro-peace son, Nicholas. The pro-Nazi fascist Hungarian Arrow Cross leader, Ferenc Szálasi, was placed in control. As the result of German occupation, Hungary's Jewish population, previously protected by Horthy, was given over to the death camps in the last mass murder campaign of the war. Orchestrated by *SS-Obersturmbannführer* Adolf Eichmann, over 430,000 Hungarian Jews were exterminated in less than two months.

During the late war German-Russian battle over Budapest, most of the Division *Maria Theresia* was destroyed, including its commander, *Brigadeführer* August Zehender. One section of the division managed to survive a fighting withdrawal and was able to surrender in Salzburg, Austria, to US forces.

After the war and during the war crimes tribunals, while the SS itself was classified and prosecuted as a criminal organisation, the equestrian SS as a whole were exempted due to spurious German testimony and a defence promoting the argument that the SS riders as 'equestrians' were involved in non-military sporting activities. This apparently convinced the court and therefore its members were allowed to go unpunished for its crimes of mass murder.

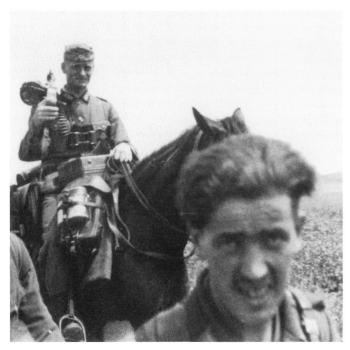

Left: **Machine Gunner on Horseback**
Somewhere on the Eastern Front, a cavalry trooper shoulders a double-magazine-fed MG-34/42. His saddle carries a boxed field telephone along with a messenger satchel and a field food container.

Below: **Frozen in Time**
A Trakehner and its rider float over a wintry landscape.

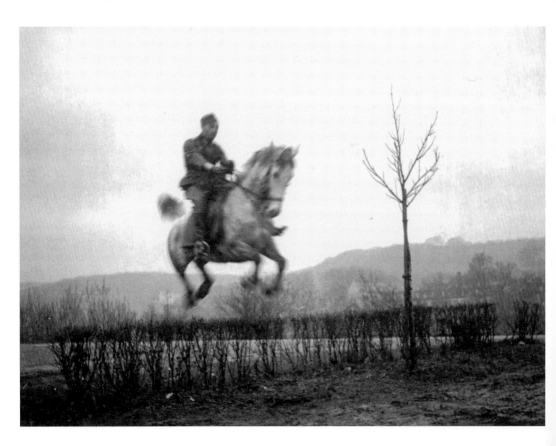

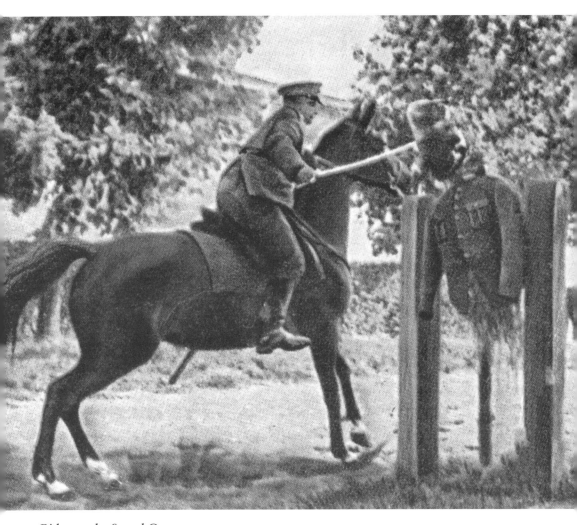

Rider on the Sword Course

Appearing as one of 270 collector cards offered as 'perks' with Dresden-made Mokri Superb cigarettes, the illustration contains a caption on the reverse that reads: 'The exercise includes cuts and thrusts against dummies ridden past at all gaits. They represent a standing, kneeling or prone enemy.' The sword-wielding soldiers have decapitated the straw-stuffed dummy, which is oddly dressed in a German Army uniform.

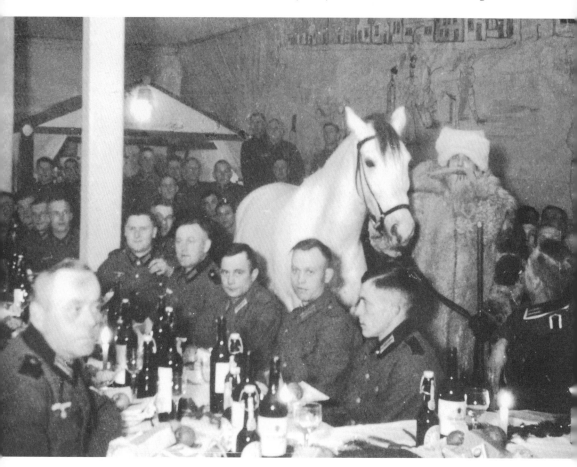

Holiday Horseplay

With tables laden with bottles of wine and beer and the walls decorated with the soldiers' own artwork, Father Christmas has brought his horse to a holiday dinner party.

The official Nazi guide to practicing Christmas sought to twist the holiday to its own purposes, including replacing the Star of Bethlehem with the swastika. Even traditional carols saw their lyrics submerged beneath words more attuned to the 'blood and soil' pagan roots of the new Nazi creed. These and other instructions were detailed in a twenty-page pamphlet distributed to general Party functionaries so that they might guide the German public in the effort to eradicate dependence on the Judeo-Christian religions.

However, it appeared that Father Christmas, beard and all, was still in favour – even when Hitler himself visited a 1937 celebration, during which he was photographed with two Santas offering him gifts. The event was organised by the *Heimatwerk*, founded in 1936, whose programs touted Saxon-German culture as examples of 'True Germaness'. They envisioned the new Nazi Christmas to be 'celebrated without Christ, but as a Germanic-fertility jubilee'. As in all Nazi-era propaganda, the focus was shifted to Hitler as the only Messiah and Saviour of the pure German *Volk*.

Hitler himself was a lapsed Catholic who often stated that he felt 'providence' was on his side, especially after surviving several assassination attempts.

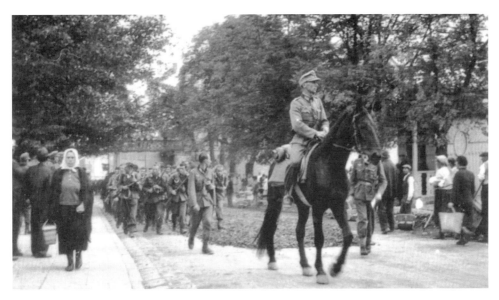

Stereoview – Poland
Led by their mounted commander, young German soldiers gaze about like tourists as they enter a Polish town in 1939. The image appeared as Picture Number 81 in a series of stereoview cards titled *Die Soldaten des Fuhrers im Felde* and credited to Heinrich Hoffman, Hitler's personal photographer.

The German occupation of Poland would result in the murder of over 6 million civilians as the Nazis sought to obliterate Polish culture, including its Polish clergy, military, political and educational leadership and its 3 million Jewish citizens, for which in great part it was successful.

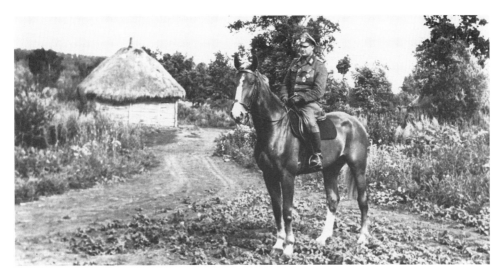

Local Scenery – Poland
A cavalry officer poses with his sleek thoroughbred, perhaps a Hanoverian, somewhere in Poland, whose own mounted cavalry faced off against German Panzers in an uneven match. The soldier, wearing both First and Second Class Iron Cross and Combat Assault awards, has chosen a 'typical' Polish thatched farm hut as background scenery for his souvenir photo.

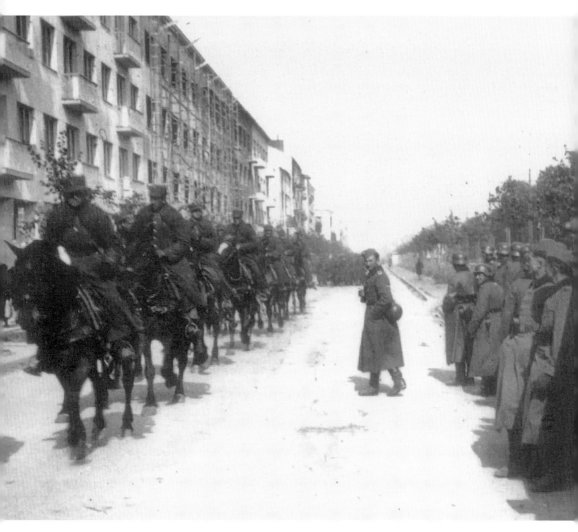

Polish Cavalry Surrendering in Warsaw

A German soldier intent on a photograph steps into the path taken by the long line of Polish POWs as they ride or march into captivity. Although initially blamed on the Germans, Polish officers were among the thousands eventually murdered in the Katyn Forest by Soviet NKVD execution squads. Stalin's Russia was a temporary non-belligerent during the joint invasion of Poland, which was made possible via the notorious Molotov-Ribbentrop Non-Aggression Pact – a short-lived agreement by which Stalin and Hitler would join forces to carve up Poland, with both unleashing slaughter upon its military and civilians. Less than two years later, Hitler would turn on his erstwhile Soviet ally and seek to visit the same carnage on its people as he had visited upon the Poles.

MARSHALL ISLANDS

Invasion of Poland 1939

W1.(1-1) 1989

Polish White Chargers against German Tanks – September 1939

The 60th Anniversary Commemorative Special Single Stamp issued on 1 September 1989 was the first in a series chronologically depicting 100 major events during the Second World War. The duration of the series, published by the Marshall Islands Postal Service, spanned six years – the length of the war itself. The Marshall Islands initially relied on stamps from Germany and then from 1914 to 1944 reverted to Japanese postage. After the end of the Second World War the islands became part of the US Trust Territory of the Pacific.

The story of Polish lancers charging German Panzers is now considered one of the 'myths' of the war. However, it may be based on the courageous actions of the Polish 18th Lancer Regiment (part of the Pomorska Cavalry Brigade), who set themselves against a German infantry position near the town of Krojanty in Pomerania on the first day of the invasion. Purportedly, the Polish charge caused a delay in the offensive of the German 20th Motorised Infantry Division. All turned against the 18th Lancers when they later encountered German armoured vehicles. The losses included the death of the regimental commander, Colonel Kazimierz Mastalerz.

The 'lances against tanks' story took hold as a result of an initial report by an Italian journalist brought to the scene by the Germans and who penned a report that apparently lost something in translation. In addition, a German propaganda film, intended to cast the Poles in a negative light for using primitive weapons, only amplified the 'heroic' appeal of the story. Produced in 1940, the so-called documentary was entitled *Schlachtgeschwader Lützow* (Battle Squadron Lützow), which was traceable to the Prussian General Adolf von Lützow, for which the squadron was named. The film featured dramatically staged charging cavalry versus tanks. However, lances had been long abandoned by Polish forces by 1939. Instead, they had been replaced by vintage Tsarist-era Russian 3-inch guns, which served as anti-tank artillery pieces that initially proved effective against the German panzers.

The Lützow name was apparently revived in February 1945 as used by the 37th SS Volunteer Cavalry Division *Lützow*, formed from the survivors of the SS *Florian Geyer* and *Maria Theresia* divisions, although its less than elite members were mostly Hitler Youth and Hungarian *Volksdeutsche*. Formed into under-strength regiments, it saw action against Red Army forces in the very last days of the war before its remnants surrendered to US troops in Austria.

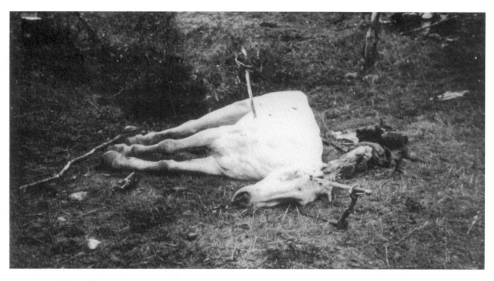

Mercy or Murder?
What appear to be Polish cavalry swords pierce the body of a white warhorse. While it's possible the animal may have been injured in battle and was thus put out of its misery, however gruesomely, there also appear to be signs of a gunshot wound to the centre of the head. While the Polish cavalry still carried swords, they served only as ceremonial duty for the Germans. Furthermore, as the swords were left behind, it would indicate that their owners had become casualties, with the victors then wielding the blades. Since the photo was taken by a German soldier, it may indicate who thrust the swords.

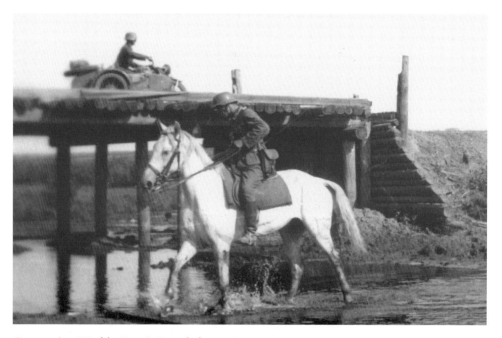

Contrasting Worlds: Russia Invaded – 22 June 1941
As a motorcycle rolls over a nearby bridge, a German cavalryman tests the waters.

Overview

German soldiers fill their wooden water barrels while their horses find relief from the Russian summer heat.

In preparation for the attack on the Soviet Union, the Wehrmacht amassed 3 million troops, 3,350 tanks, 2,000 aircraft and 600,000 other vehicles. Matching if not exceeding the number of machines was the number of horses, which is estimated to have been from 600,000 to 750,000. Local horses were requisitioned once within Soviet territory, but directives pointed out the need to leave enough draught animals for the inhabitants to produce the food necessary to feed their invaders. Adding to the stress on the native Russian livestock was the destructive effect of the previous 'terror famine', caused by Stalin's collectivisation program of 1928–33, which brought about a disastrous 47 per cent decline in the Soviet Union's horse population from 32 million to 17 million.

New Recruits

A massive shaggy-legged draught horse, perhaps an example of the *Schwartzwalder Fuchs*, seems to dwarf a smaller cavalry mount as they enter their stables.

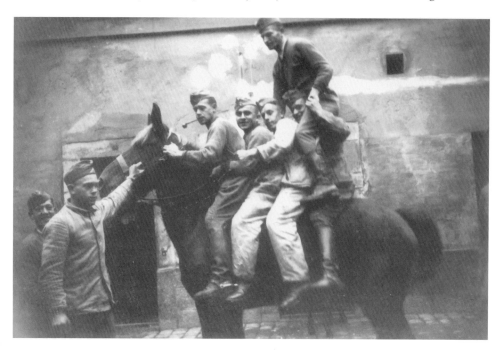

Ross und Reiter – **Horse and Rider**
Soldiers of the 4th Regiment Artillery clamber aboard a draught horse large enough to accommodate five of them. In addition to *Pferd*, *Ross* is another German term for horse and is an example of geographical and social variations of the language. German is considered the most variable of European languages and counting some half a million words – a number affected by its agglutinative nature, whereby it is common to string words together to form new words.

Wagon Field Depot with Camouflage Tents
A sea of wooden-wheeled wagons await their beasts of burden.

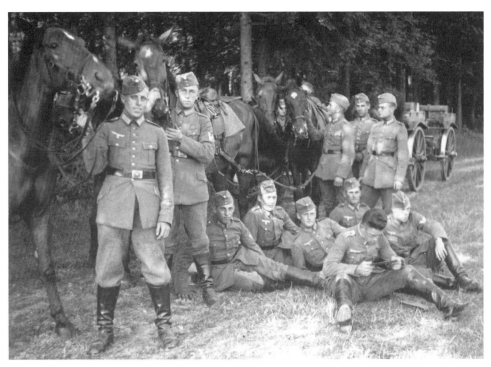

Rest Stop
A group of privates and corporals, wearing their overseas caps, stop for a photo somewhere along a forest path.

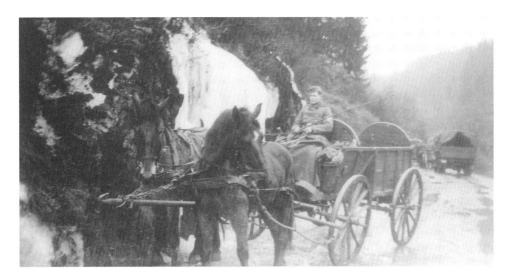

The Past Passes the Present
As if a metaphor for the growing dependence on horsepower, a horse wagon passes trucks on an icy mountain road. Since motorised vehicle production could not keep pace with their losses, horses filled the need. Here a wagon's wooden wheels are visible while the heavy-duty iron or steel-constructed wagons roll on steel wheels, some equipped with pneumatic rubber tyres.

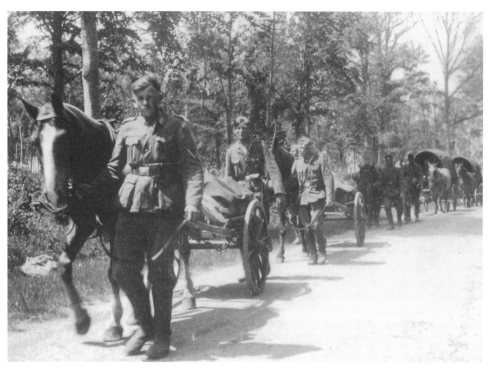

Wagon Train
Small wooden-wheeled carts (*fuhrwerke*) and local wagons have been pressed into service. Note that the soldiers also walk rather than ride. The lack of helmets indicates summer heat and the apparent lack of enemy threat.

Pneumatic Chariot
Bridging two eras, a horse-drawn passenger cart has been designed with modern automotive tyres.

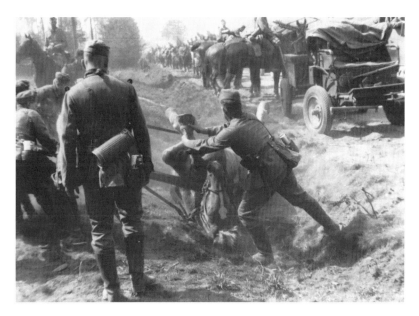

Rescuers
A wagon horse has tumbled into a French roadside ditch, where it is thrashing in distress as soldiers struggle to keep it from further injury. Another view of the pneumatic-wheeled carriage design is visible on the roadway, along with a seemingly unending line of horse-mounted troops. Note the distinctive ribbed gas mask canister slung over the soldier's back – a vestige of gas attack fears prompted by the First World War.

Horse-Drawn Kitchen
German soldiers grimly ponder the contents of a small mobile field kitchen that has brought them a hot meal. Two horses pulled the 0.75-ton HF.12 kitchen on wooden wheels. Variations of the two-wheeled cart design were configured for use by communication units, engineers and for other troop service needs.

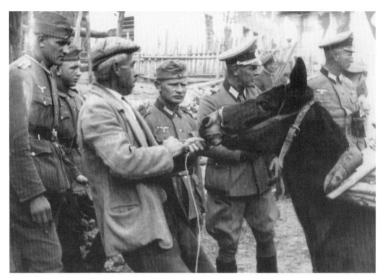

Balking Resistance
A German major finds himself caught in the middle of a scene involving a Balkan civilian and his non-cooperative pack animal.

Greece – Souvenir Photo
A *Luftwaffe* man wearing sunglasses is seen making the acquaintance of a donkey, apparently to the amusement of a local man and boy. The soldier is identified by notations on the reverse of the photo as *Unteroffizier* (NCO) Ichmiel and his tunic carries the *Luftwaffe* Air Crew badge. The notation also indicates he was later killed on 3 June 1942 – the same day SS/SD leader Heydrich was dying from a British-trained Czech resistance assassination, which was conducted in Prague.

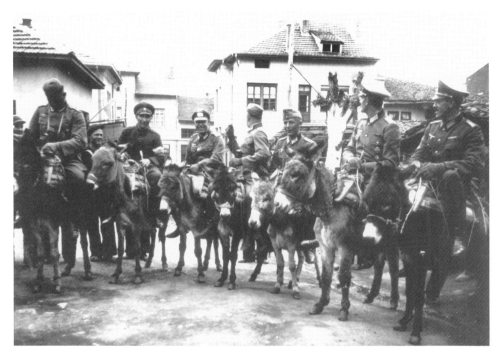

Donkey Division

Several soldiers showing Iron Crosses and wound medals prepare for an outing riding a small herd of donkeys somewhere in the Balkans.

In 1941 German forces delayed their plans for the Soviet invasion to come to the aid of their Italian allies when the latter failed in their efforts to occupy Balkan territories, including Yugoslavia and Greece. Hitler had tried to restrain Mussolini from such poorly thought out and ill-equipped actions, but *il Duce* eventually launched the assault, seeking to realise his dream of a new Roman Empire. The Italians met stiff Greek resistance and suffered heavy losses. German forces intervened in early April 1941 and by the end of May had occupied Greece, which suffered 15,000 military dead, as compared to some 1,500 German deaths. An estimated 300,000 Greeks would later die from mass starvation while 65,000 of its 75,000 Jewish citizens perished in German death camps.

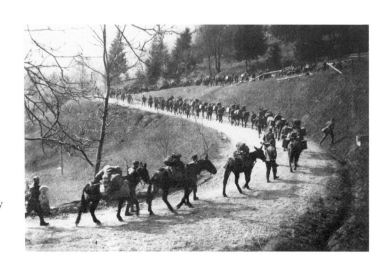

Pack Train

Mules wind their way up a mountain track, their packs burdened with equipment.

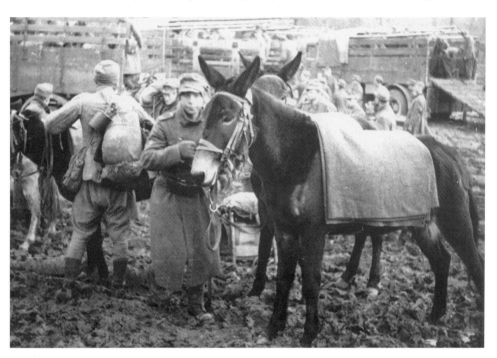

Close Friends
A young muleteer appears to be preparing his mule either for loading or unloading from one of the transport trucks. The muddy ground is pockmarked with the tread of many animals.

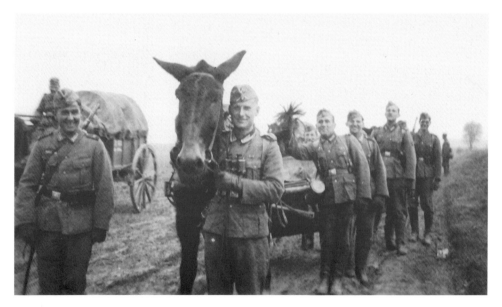

Good Spirits
A soldier, wearing the collar insignia of a *Feldweber* (NCO), has paused for a photograph while trekking through Russia with a mule, unaware of his comrades' rearguard action. NOCs were often supplied with both a sidearm and binoculars as emblems of their rank.

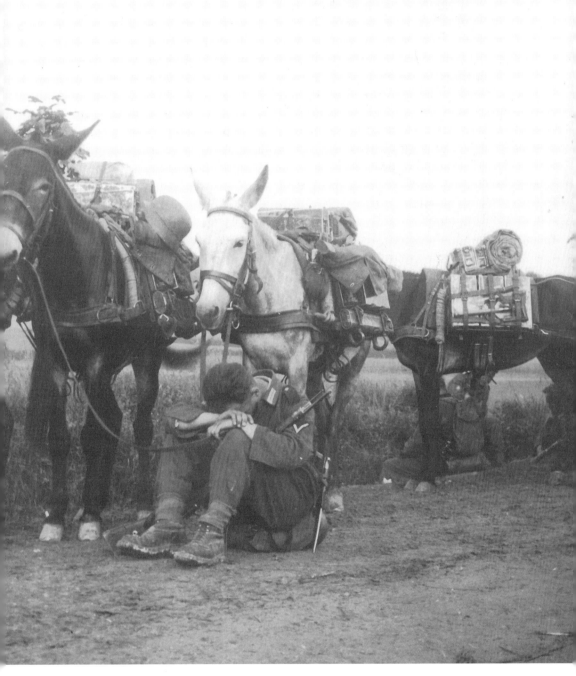

Nap
A corporal, still clutching his rifle and the mules' reins in his hand, sleeps sitting on his backpack on a muddy Russian road as his charges eye the cameraman.

High Altitude Horsemanship
A staff sergeant of the *Gebirgsjäger* rests atop a heavy-duty wicker basket, as carried by the sure-footed mules.

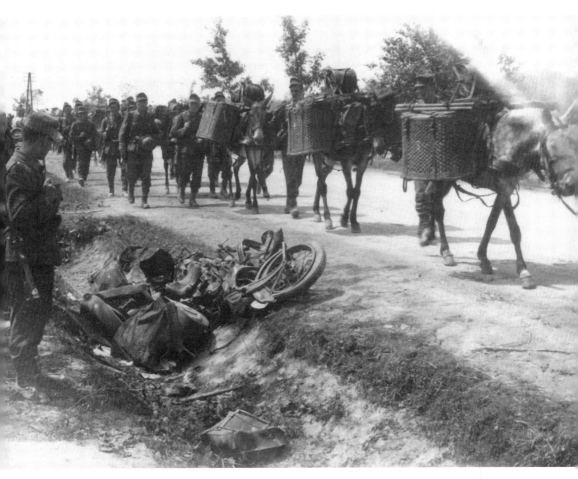

Wicker Baskets and Wrecked Motorcycle

Led by members of the *Gebirgsjäger* mountain troops, a caravan of mules carrying spools of field radio wire plod by the remains of a mangled German BMW motorcycle.

The designation *'Jäger'* (*Jaeger*) is traced to pre-First World War units that were initially made up of men originally involved in forestry work and who gained a reputation as better than average troops. By the end of the 1800s, Prussian Army horse-mounted dispatch riders were termed *Detachment Jäger zu Pferde*. Eventually, the term represented light infantry or riflemen, and was even the term for fighter aircraft. Other variations included *panzerjäger* for anti-tank forces, while *Gebirgsjäger* referred to mountain infantry and *Fallschirmjäger* referred to airborne paratroopers.

On Command

A *Gebirgsjäger* (mountain trooper) exhibits the attacking power of his mule.

The Americans relied more on mules than horses, finding the sturdy hybrids far less prone to illness, requiring less food, heartier in constitution and performance and less affected by the loud noises of explosions. After the First World War, Germany's battlefield foes calculated that horses were antiquated weapons with no place in modern warfare and that their support expenses would siphon funds away from other military activities. In great part American industrial might was able to meet and re-supply all their mechanised needs with an unending stream of transport trucks with enough surplus to augment the needs of both the British and the Soviets.

Panjewagen

In Russia, two German soldiers have requisitioned a local horse. When the numbers of German horses were reduced by the harsh conditions, the smaller Russian *panje* or *Bashkir* pony was found to be an excellent substitute. The high destruction rate of German motorised transport during early 1942 on the Eastern Front forced increased reliance on such means in order to supply mechanised troops who had now been dismounted and were fighting on foot. Of the 11 million horses within the areas of the Soviet Union occupied by German forces, 7 million were either commandeered or died.

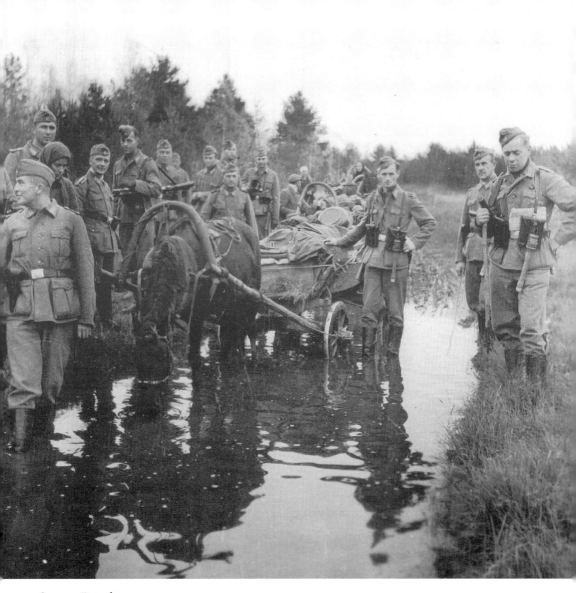

Swamp Patrol

Carrying distinctive 'potato masher' German hand grenades, soldiers are seen investigating a Russian *panje* wagon somewhere in the Pripet Swamps. The vast area was used as a refuge by fleeing civilians as well as partisans and Red Army stragglers. German sweeps of the area resulted in the deaths of thousands, with the term 'bandit' acting as a catch-all euphemism to justify the murder of any individual falling within Nazi racist ideology. The term allowed the Germans to treat the individuals as criminals, which thus exempted them from the rules of treatment for regular POWs, often resulting in execution.

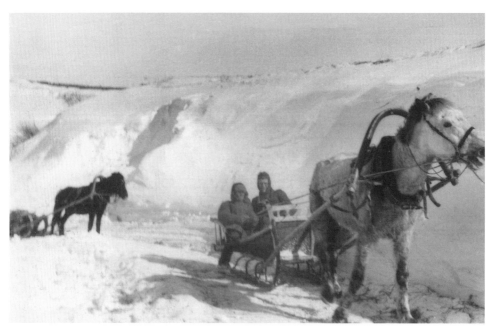

Panjewagen in Winter
Wheeled wagons have been replaced with sleds as the Russian winter descends on man and horse.

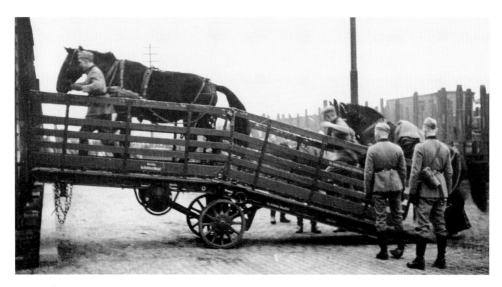

Toward the Front
Horses often travelled by rail, along with the tons of fodder needed to feed them. These draught horses, as indicated by their size and harnesses, appear well-fed, but the deteriorating conditions of supply would soon contribute to their suffering and deaths.

Fodder for horses was calculated at three kilos (6.6 lbs) per horse per day. If not found while foraging or supplied by rail shipment, delivery by air drop was employed with varying degrees of success. However, due to ever-shrinking food supplies, horses sometimes had to subsist on short rations, with the animals certainly feeling the effect.

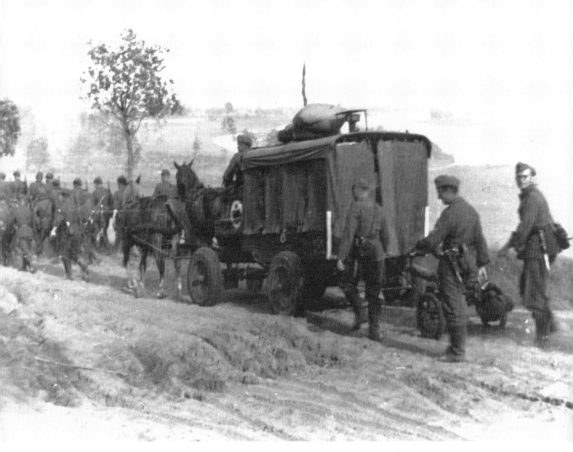

Ambulance

A horse-drawn medical unit follows in the wake of marching troops. The structure of the German battlefield division incorporated two medical companies: one motorised field hospital (*Feldlazarett*) with provisions to care for 200 patients as well as thirty motorised or horse-drawn ambulances as part of the transport units (*Krankentransportabteilungen*). At the outset of the war with the invasion of Poland, while the motorised ambulances were able to keep up with the fast pace, the horse-drawn units couldn't. Horses were also employed to carry the wounded on improvised litters.

In determining the priority of care, especially during heavy battlefield engagements, those soldiers suffering from intra-abdominal or intra-cranial wounds were left unattended in favour of those less seriously injured, and thus more likely to survive and return to duty. A major contributing factor of the prevalence of infections was an apparent lack of hygiene administered by the medical staff, which was a result of too few and insufficiently well-trained doctors facing an increasing overload of wounded.

Second Summer in Russia – June 1942
As a soldier readies their mounts, the officer and his adjutant, who wears an Iron Cross Second Class ribbon, stand on the steps of a typical log-construction Ukrainian farmhouse, which in this case has been converted into the headquarters of the 'Chief', or Commander, as written on the posted signage. Handwritten notations on the reverse of the photograph identify the medical officer as a Doctor Witthauser.

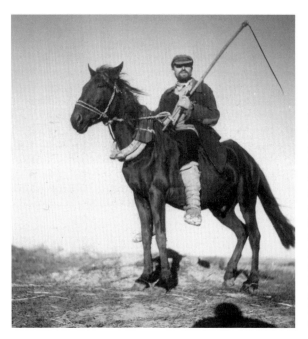

Russian Farmer with Scythe
The shadow of the German cameraman intrudes upon the scene as a horse-mounted farmer complies for a photo. We can imagine the photographer chancing upon the individual and realising the inherent impact of the image, but perhaps not the portentous meaning behind the scythe and the ultimate fate of hundreds of thousands of German soldiers who would be cut down by the Soviet forces as the tide of war reversed direction.

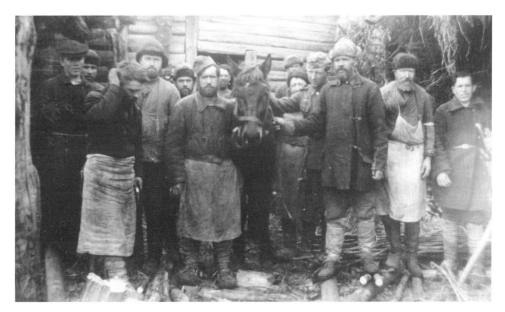

Prized Possession
A solitary German soldier is almost lost among a large group of Russian peasants. Their aprons indicate a workshop of some kind, perhaps a blacksmith's. Relations between regular German soldiers and Russian villagers were initially often friendly, with many welcoming them as liberators from Stalin's terror, until the true nature of the Nazi plan to strip the land bare, murder, starve and enslave its people eventually turned the civilians against their occupiers.

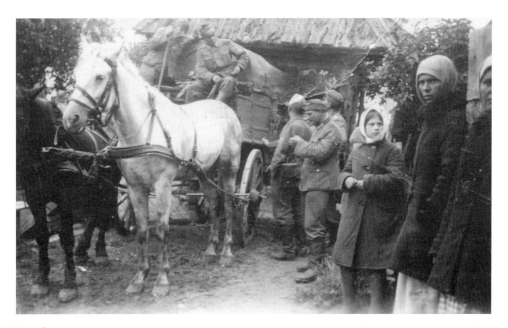

Invader
Russian womenfolk look on apprehensively as German troops, including a horse-drawn supply wagon, appear in their village.

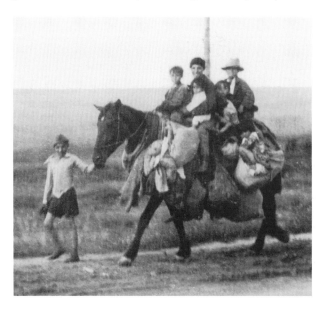

Mass Transportation
Several children piled aboard their heavily laden horse still manage to smile for the German camera. The boy at the lead appears to be wearing a Russian military cap.

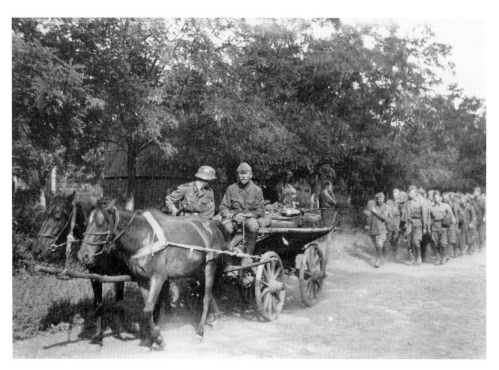

Death March
A pair of horses haul a Russian wagon carrying a lone German corporal as guard while a Russian POW handles the reins. A disabled motorcycle can be glimpsed as cargo. The soldier is reaching for his rifle as he notices a Russian civilian standing by the roadside, over which trudge legions of Red Army POWs. Captured by the hundreds of thousands during the early months of the June 1941 Soviet invasion, more than 3 million will die from deliberately imposed starvation, while all Soviet political officers, men and women, were summarily executed.

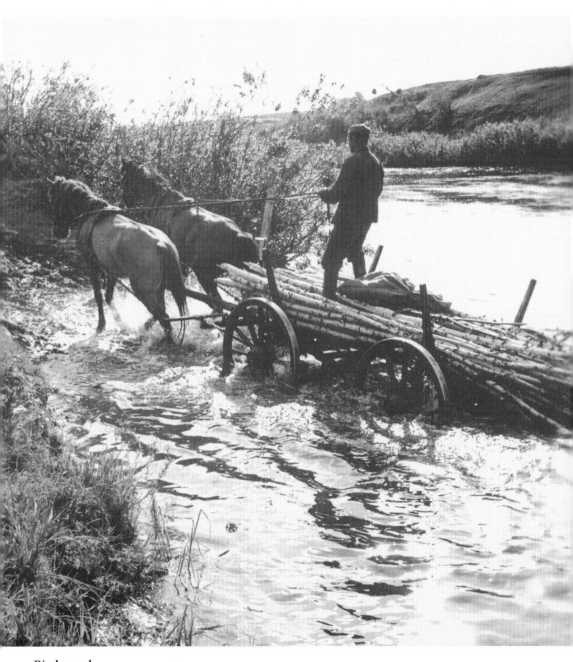

Birchwood
A German soldier uses a Russian wagon to transport birch saplings across a shallow river. The prevalent birch forests provided building material for the soldiers' bunkers and were also often used for fashioning grave markers, the German cemeteries eventually growing into vast forests themselves.

Officer's Horse

Horse-mounted soldiers wore grey uniforms with leather trim as well as tall riding boots without the hobnails of the foot soldier's marching footwear. After completion of cavalry rider training, the riding boots were fitted with buckled spurs – a tell-tale identification when viewing photographs from the era. The officer also wears an early style soft 'crushed' cap.

Initially, all horse-mounted soldiers carried sabers in a leather pouch; however, after 1939 officers were issued the MP-38/40 submachinegun. All others carried the Mauser Karabiner 98k carbine, a modified version of the long standard 98a – its shorter length making it more suitable for mounted troops. The carbine was based on an 1898 design, accepting five rounds pressed into its integral magazine. As such it required the manual opening and closing of the bolt-action to eject a spent round and cycle a new cartridge into the chamber, whereas the standard US issue Garand infantry rifle, an advanced gas-operated semi-automatic design, required no time-consuming bolt action and thus increased its rapid fire power. Many veterans on both sides agreed this design advantage often made the difference between life and death on the battlefield.

Along with the carbine, German officers, sergeants and medical personnel carried the Pistole 08 – a 9 mm semi-automatic that is better known as the iconic 'Luger'. The Luger was itself later replaced by less expensive to produce P-38. Some horse troops were issued with the new select-fire 'assault rifle', the *Sturmgewehr 44* – the predecessor of the modern infantry weapon of today. Each squad of horse soldiers also included nine troopers manning a MG-34 light machinegun. They later upgraded to the MG-42, which was known as 'Hitler's buzz-saw' because of its high, cyclic rate of fire.

High Contrast
Horses and riders cut dark silhouettes into a snow-blanketed landscape.

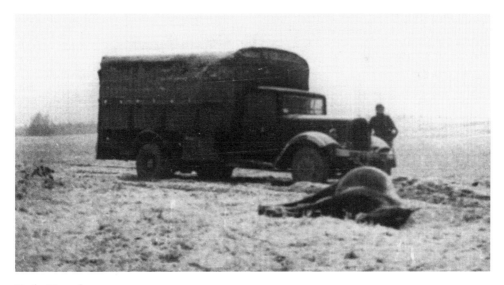

Early Casualty
A German truck and a fallen horse share a desolate, snow-covered Russian field. The soldier wears summer uniform gear, indicating the first winter of the invasion.

In an arrogance that would prove costly, the German military command counted on a quick victory over all Soviet resistance. Hitler, believing Communist Russia would 'fall like a house of cards', meant that German troops were supplied with summer uniforms only, which left them totally unprepared for the Russian winter and -30 degree Fahrenheit temperatures that froze the oil in the cannons and the blood of the soldiers.

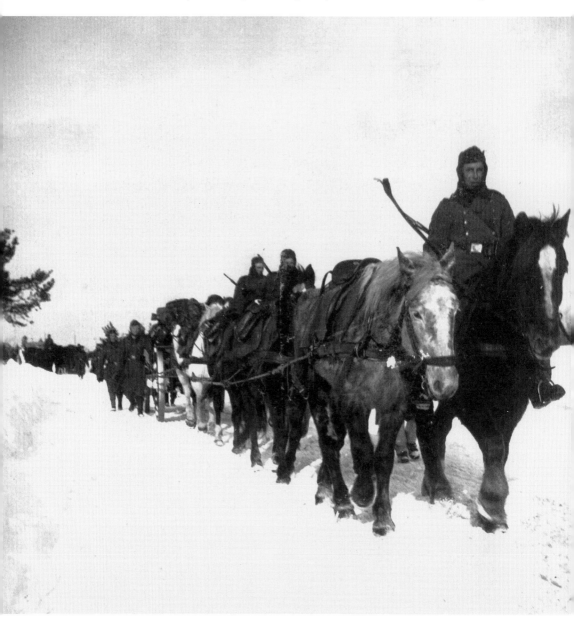

Ice Hooves

Of the 500,000 wheeled motor vehicles driven into Russia, 85 per cent were no longer operational by mid-November 1941. Subsequently, horses were, in effect, the only reliable means left.

A draught horse takes the lead here, while a smaller Trakehner shares the load. As a result of the perilous weather conditions, as well as combat losses, around 700 horses died every day during the invasion.

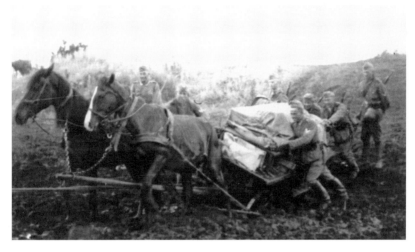

Manpower

With the arrival of the Russian autumn and spring rainy seasons (*Rasputitsa*) came the sea of all-engulfing mud. A pair of horses, their rib bones showing, struggle to pull a cargo wagon that has become bogged down in the morass. As the wagon wheels sink deeper, threatening to topple its load, the soldiers, either grinning or grimacing, lend a helping hand. A tall *Obergefreiter*, arms behind his back, seems to stand to the side, observing his comrades' efforts.

Quicksand

Submerged to their chests, two horses are trapped in a bog. Six large horses were needed to haul the heavy iron Hf.2 transport wagon, which itself rolled on solid steel wheels. In Russia it earned the nickname of the 'Horse Killer'.

 During the war, 70 per cent of all transport and supply, including heavy artillery, was horse drawn. Due to their size and the fact they were often tethered to heavy transport wagons and field artillery, horses were left to take the brunt of air attacks while their human counterparts sought cover. When rendered unfit by the rigors of traversing huge distances, the harsh climate, disease and food deprivation, horses were often slaughtered on the spot and were fed to their human taskmasters.

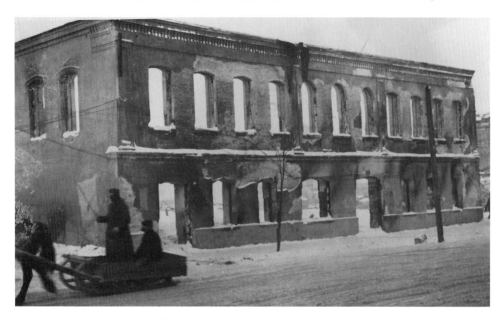

The Return of Winter and the Façade of Victory
German soldiers, wrapped against the winter cold, travel past the façade of a burnt-out Russian building. The small sleds adopted for use on the Eastern Front were called *Pulk* from the Finnish *pullka,* a term for a low-slung toboggan, and the utilitarian device was pulled by skier, dog or reindeer. Russia's perennial ally against invaders, 'General January and General February', would take its toll yet again, with hundreds of thousands of cases of incapacitating frostbite often requiring amputation being reported during the Russian winters.

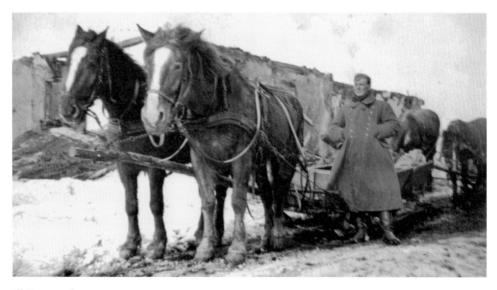

Ill-Prepared
Amidst the rubble of a devastated Russian village, large draught horses have been tethered to a makeshift sled. Their relative good condition and the summer uniform of the driver indicates the photograph was taken during the first Russian winter. Far worse was yet to come.

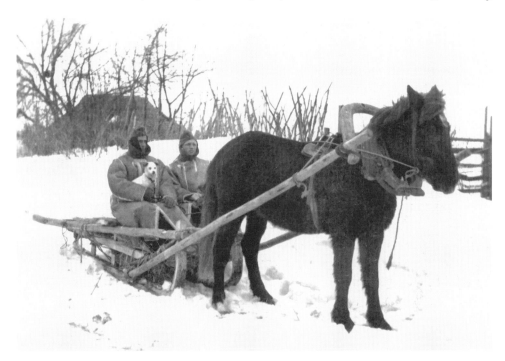

Russian Horse, Russian Sled
German troops now wear lifesaving, heavily padded sheepskin winter coats, replacing the thin summer cloth overcoats worn during the first winter of the Soviet invasion. One soldier holds a leash attached to a dog – both a pet and an early warning system against Russian infiltrators.

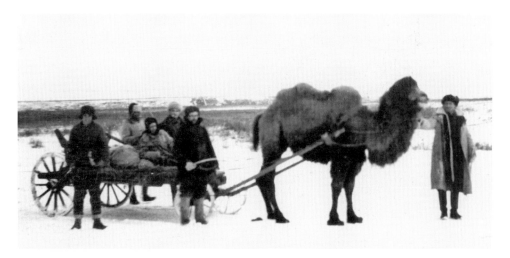

Alternate Means
Seen in various items of clothing during a Russian winter, these German soldiers have embraced a rather unusual means of transportation. Camels were prevalent in the Asiatic parts of the Soviet Union. One, named Kuznechik, became famous when it and its Red Army driver took part in the fighting at Stalingrad. They survived the ensuing battles and made it to Berlin for the final victory.

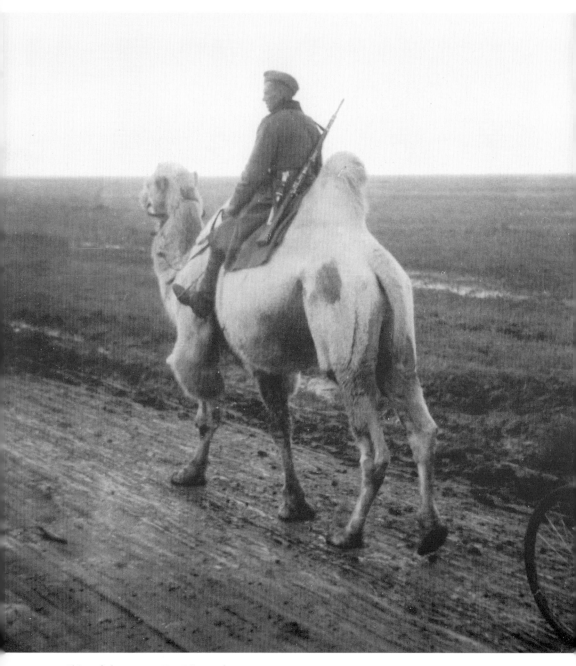

Ship of the Desert Re-Directed

A soldier in Russia has commandeered a camel, which is well-suited for the muddy seasons that can swallow wheeled vehicles.

The American military experimented with the use of camels during 1855–66, beginning with thirty that were brought back from Egypt. Found well-suited for the Southwest's climate and terrain, they fared much better than horses and mules. Testing was conducted in Texas and California and generated high praise for the camel's endurance and weight-carrying. The Civil War ended the program but many wild camels roamed the area into the early 1900s.

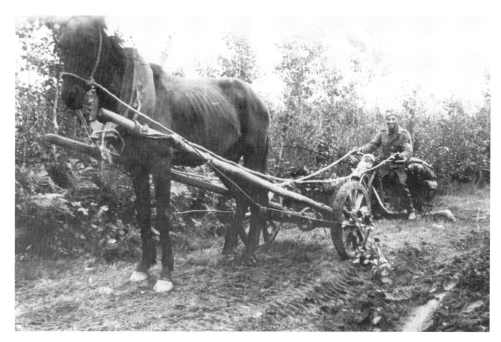

One Horsepower
An undernourished horse is used to extricate an 'iron horse' in the form of a BMW motorcycle that has apparently either succumbed to the mud or run out of fuel – an ever-increasing supply problem that would eventually hobble the mechanised elements, particularly the vaunted panzers.

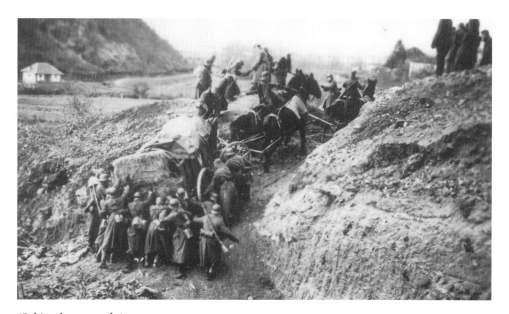

'Schiesekommando'
Pencilled notations on the back of this photograph colourfully describe the job given to this group of soldiers. The image is reminiscent of a modeller's recreation, with the figures toy-like in appearance.

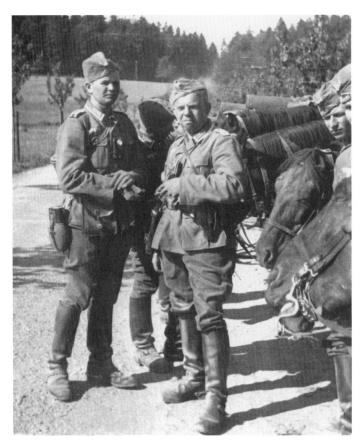

Saddle Weary
A pair of NCOs glare into the camera, their sagging, spur-equipped boots evidence of the rigors of the long campaign.

After the ravages of the 1941–42 Russian winter campaign, the 1st Cavalry Division became the 24th Panzer Division, functioning as divisional reconnaissance battalions (in effect, as the last of the German cavalry). As they were often sent into the fiercest battle situations, they earned the honorary title of 'division fire-brigade', since they were called upon to come to the aid of besieged troops and quell the most intense battlefield engagements.

In March 1945, during the last weeks of the war, the 1st Cavalry troops took part in 'Awakening of Spring', which was launched along the Danube. The defensive operation ultimately failed, and the troops surrendered to the British in Austria, with a final horse march taking place through Wurttemberg in June 1945. Kept briefly as POWs, they were soon released, and their horses returned to the fields under the care of local farmers. After being implicated in the plot to assassinate Hitler, the troop's commander, General Gunther 'Hans' von Kluge, had committed suicide in 1944. Despite strongly opposing Hitler and his genocidal war of ethnic cleansing, his lack of commitment contributed to the failure of the various anti-Hitler plots.

The horse-mounted cavalry itself was soon consumed, leaving the bicycle and motorcycle troops to carry on their reconnaissance and scouting duties. By the second half of the war, the horse platoons had fallen from three to two squadrons. However, they proved exemplary in performance when reorganised as three cavalry regiments, eventually seeing action as two cavalry brigades in 1944 during the German retreat and final battles of the war. Credit for their successful performance is given to the leadership of Major von Boeselager and the ill-fated General von Kluge.

Backdrop to Collaboration
A Russian soldier poses for a souvenir photo as a Cossack via a painted backdrop. The photography studio's illustration includes a traditional wool cap and an ornate *Shaska* saber. As anti-Stalinists and pro-Ukrainian nationalists, many Cossacks initially volunteered to don the German uniform while others fought as members of the Red Army.

 One of the last horse charges of modern warfare occurred in November 1941, six months after the June invasion of the Soviet Union. It took place outside the village of Musino as the Wehrmacht marched relentlessly toward Moscow. From a line of trees a half mile away, a phalanx of saber-wielding Russian cavalry launched themselves against German forces of the 106th Infantry and 107th Artillery. Of some 2,000 horses and men of the Mongolian 44th Cavalry Division, only thirty even reached the German line, where these last survivors were themselves finally shot down. It was over in ten minutes.

Nr. 2619 Deutschland € 1,80 Österreich € 2,05 · Schweiz CHF 3,50

DER LANDSER

www.landser.de

Erlebnisberichte zur Geschichte des Zweiten Weltkrieges

W. Brockdorff

Der letzte Reitergeneral

**Generalleutnant Helmuth von Pannwitz – Als Kommandeur
einer Kampfgruppe der 4. Panzerarmee (Hoth) unterstellt**

Opposite page: 'The Last Cavalry General'
The cover illustration of the post-war West German publication *Der Landser* depicts Helmuth von Pannwitz, a commander serving in the 4th Panzer Army, galloping into battle against Soviet forces alongside his Cossack recruits. Some considered the Cossack as 'true cavalry', while the German cavalry in effect were 'mounted' infantry.

Helmuth von Pannwitz, a First World War cavalry officer who was promoted to lieutenant at the age of sixteen, rose to Lieutenant General in the Third Reich. As leader of the 15th SS Cossack Cavalry Corps, he was the recipient of the rarely awarded Nights Cross with Oak Leaves. Very popular with his troops, he also voiced his opinion against the prevalent Nazi view of Slavs as subhumans. He and his surviving men and their families eventually surrendered to the British and, despite promises to the contrary, were forcibly repatriated to the Soviets, who considered them collaborationists and traitors. As a result the common soldiers received at least eight years in the Gulag, a potential death sentence, while the higher ranking officers were hanged. The corps leader, General von Pannwitz, who had chosen to remain with his troops although he likely could have escaped, was charged with war crimes as committed by his troops during anti-partisan actions in Serbia and Crotia, and was executed by the Soviets after a show trial in Moscow in 1947.

The publication *Der Landser* was produced by the former *Luftwaffe* officer and writer Bertold K. Jochim (1921–2002) and was available to readers throughout Germany, Austria, Belgium, Switzerland, Luxembourg, France and Italy. Considered a 'pulp magazine', it first appeared in 1957, with the series claiming to feature 'authentic stories of the Second World War'. Much of its content focused on the campaign against the Russians, which was characterised as a valiant crusade against communism. In this particular issue the battle described was identified as taking place near Powkovo in the summer of 1943 and concerned the Soviet breakthrough on the Eastern Front. The story appeared as a purported first-hand account by a German pilot who took part in the action.

The title, *Der Landser*, refers to the common German foot soldier. While claiming to advocate peace, its contents consistently glorified war and painted a distorted image of Nazi Germany, omitting any mention of its crimes or its repressive dictatorship. Summing up the publication's agenda, Germany's leading news magazine, *Der Spiegel*, called it 'the expert journal for the whitewashing of the Wehrmacht'. After many challenges over the years to the magazine's subject matter, the German publisher, Bauer Media, announced in September 2013 that it would at long last end its more than half-century run.

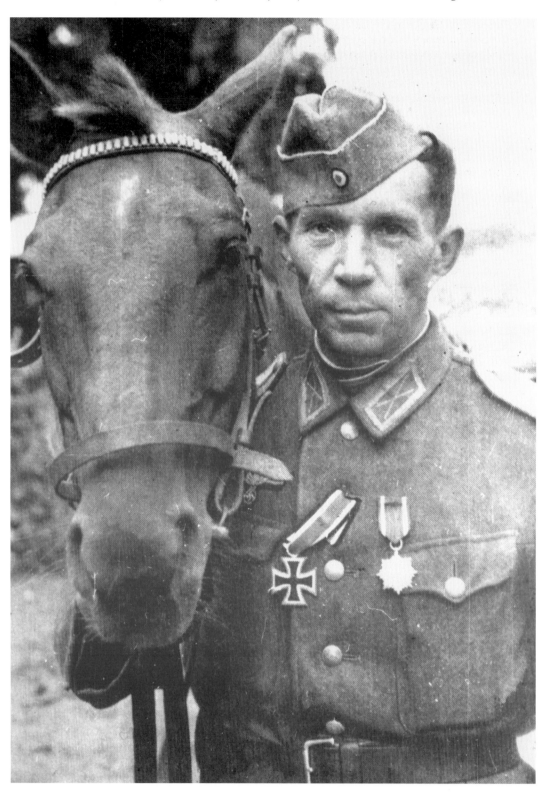

Opposite page: **Cossack with German Honours**

A Cossack volunteer wears German decorations, including the Iron Class Second Class. Upon invading the USSR, the Germans encountered the strongly anti-Soviet Don and Kuban Cossacks. Despite being POWs themselves, they were soon working to escort regular Red Army prisoners as the Germans were short-staffed and were faced with the logistical nightmare of hundreds of thousands of prisoners. This group of auxiliary guards became the 1/82 Cossack Squadron, who were formed to operate against Russian forces under German command. Their German overseers sent them to the Balkans to fight partisans, which damaged their morale as the Cossacks wanted to fight the Soviets. Other Cossack combat units were formed from other indigenous groups as well as Red Army defectors seeking to escape the deadly conditions of German POW camps.

Those who fought on the side of Nazi Germany also included the Russian Liberation Army (POA), which was led by a Red Army defector, General Andrei Vlasov. Stalin, because of his paranoia, had instigated a massive and bloody purge of his military command structure, killing thousands of top-level officers and leaving the Red Army lacking in leadership and weakened to a level that almost proved fatal to the entire USSR after Germany's attack. Stalin himself was so stunned by the attack that he refused to communicate for several days, locking himself in his *dacha* before eventually pulling himself together to rally the Russian people against the invaders.

Vlasov envisioned uniting anti-communist Russians to free the country from Stalin's dictatorship and joined Nazi Germany in the effort. By 1944 it became officially known as the Committee for the Liberation for the Peoples of Russia. Its forces reached a maximum of 125,000, including ground and air troops, although the latter was basically non-functional. Initially under German control, as of late January 1945 it came under Russian leadership. In the last throes of the war, Vlasov, believing the West's war with Stalin's USSR was imminent and hoping for recognition of his anti-communist stance, sought to surrender his troops to the Allies. In the process, Vlasov agreed to turn against his Nazi allies and fight with Red forces against the Germans during the liberation of Prague, which had been targeted under Hitler's orders for total destruction by SS forces. Although they successfully surrendered, the anti-communist Russian troops found no safety in American and British hands and they, along with their families, were forcibly turned over to the Soviets, with whom they were subjected to brutal punishment.

Another anti-Soviet Russian group formed the Cossack Corps, as led by Pyotr Krasnov, the son of a Cossack and an anti-Bolshevik commander in the Russian Imperial Army during the Russian Civil War. Krasnov had fought in the First World War with German aid against the Soviet forces, and so was not against allying himself with Nazi Germany to continue the struggle against the communists. By joining with the Germans, he hoped to form a separate Cossack state. Instead, the Germans established a short-lived Cossack puppet state in the Italian Alps at the end of the war. Krasnov, like Vlasov, surrendered to the Allies, but was turned over to the Russians, who hanged him in 1947.

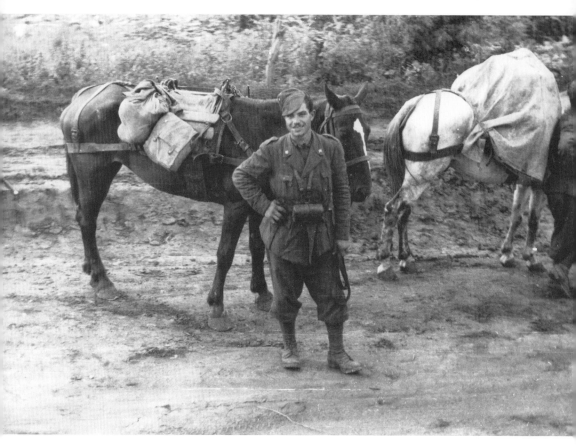

Italian Soldier – German Horses – Russian Battlefront

The soldier still manages to smile for the camera while his comrade looks on from the edge of the muddy road. Both were attached to the German *Hermann Göring* Division when it joined the 11th Panzer Division, subsequently taking part in the June 1941 invasion of the Soviet Union. As the war turned against Nazi German, the Division relocated to Italy, taking part in rearguard actions. They were some of the last to escape from Sicily before finding themselves sent back to the Russian Front in July 1944. Efforts to surrender to the Americans near Dresden failed and most were captured by Red Army forces. The survivors were kept as POWs until repatriation in 1956.

While history has indelibly imprinted the date of 7 December 1941 as the attack on Pearl Harbor and the subsequent US entry into the Second World War, halfway around the world German and Soviet forces were locked in a titanic battle for Moscow, the capture of the Soviet capitol pivotal for both military and political means. While the panzers ground within 25 km of the city, the Soviet counter-offensive denied them victory and bloodied Germany with its first major defeat of the war. On 6 December 1941, three Soviet armies – including some eighteen divisions from the Russian Far East, with 1,700 tanks and 1,500 aircraft – began a massive counter-offensive against *Heeresgruppe Mitte* (von Bock's Army Group Centre).

The German lines broke at several points, including those manned by Italian troops. While Russia sacrificed some 2.5 million men between June and August 1941 to stem the German advance, German losses were staggering as well, and among them were large numbers of Italian troops who were ill-prepared for the Russian winters. As a German Axis ally, Mussolini had ordered his own troops to join in the Eastern Front campaign. Some 200,000 left Mediterranean Italy for the harsh rigors of the Soviet Union and few returned to their warm homeland.

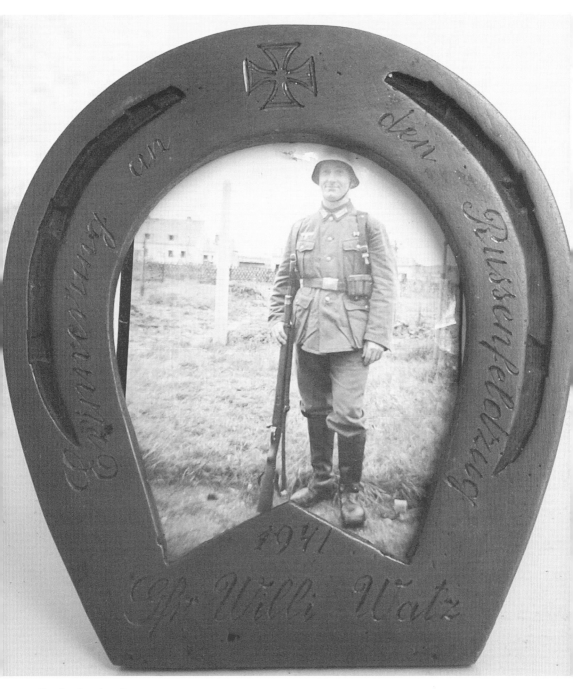

Lucky Survivor?
A solid metal horseshoe-shaped frame bears an inscription commemorating the service of Corporal Willi Watz on the 1941 Russian front, the year of the German invasion of the Soviet Union.

***Deutsche Illustrated*: Berlin – 24 March 1942**
'Soon Winter in the East will also be Overcome!' reads the caption accompanying the image of *Waffen-SS* troops who are grinning for the camera despite being caught in the frozen grip of Russia's lethal 'General Winter', which in reality was not overcome but overwhelming.

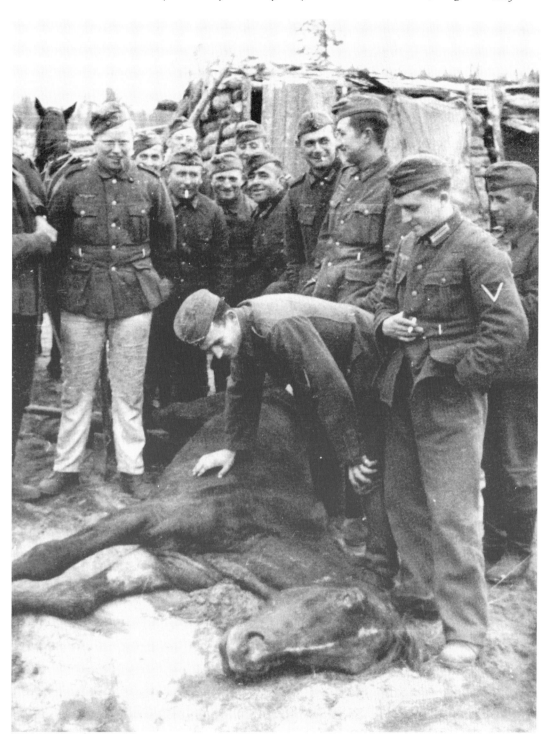

No Longer Fleet of Foot
It is not clear if the horse is exhausted, ill, dead, being tended to by the apparently amused soldiers or the subject of a proposed dinner.

On the Road from Ulm to Ruin

Along a French roadway, a German command car pauses for a cameraman to snap a photograph of the carnage stretching into the distance.

The civilian license plate (IIIZ) still affixed to the Wehrmacht-requisitioned car identifies its place of registration as Ulm-Württemberg, which is located on the Danube River in south central Germany and noted for the world's tallest church as well as the site of Field Marshal Erwin Rommel's grave. The renowned commander of the Afrika Korps had been forced to commit suicide when accused of complicity in the failed July Plot against Hitler, although his participation was marginal at best. Given the choice of a public trial and harm to his family, Rommel took the option of biting into a cyanide capsule.

Ulm was also the birthplace of Albert Einstein, who emigrated to the US in 1933, where he spoke out about impending Nazi world aggression prior to the war and also strove to rescue Jewish and other political victims of Nazi oppression. A concentration camp was established in the hills near Ulm, primarily for political opponents. The persecution of Ulm's 500 Jewish residents included the destruction of their synagogue. The city was the target of only a single RAF bombing raid. On 17 December 1944, several truck factories, more than a dozen Wehrmacht buildings, several military hospitals and 80 per cent of the historic medieval city was reduced to rubble.

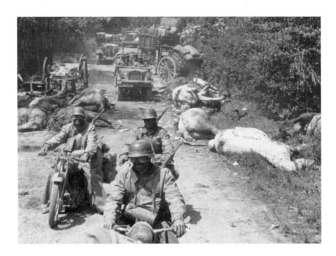

Forerunners

Motorcycle troops, often assigned to cavalry units, lead the way through a French countryside littered with the debris of war, including the mangled bodies of several horses.

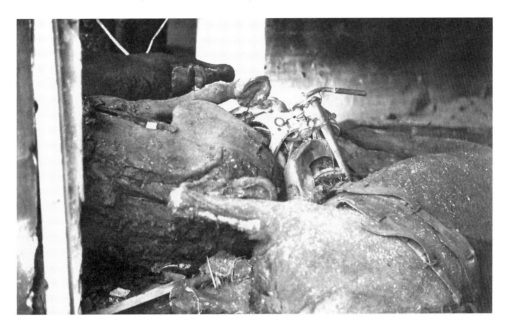

Flesh and Iron Horses
The corpses of several horses have been piled in a building along with the wreckage of a BMW motorcycle.

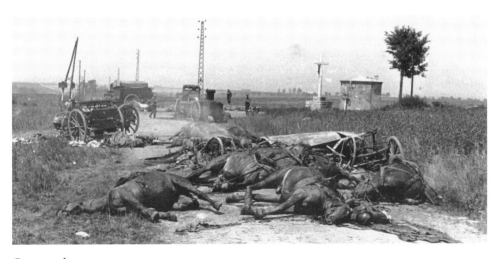

Crossroads
Rivulets of blood stain a French road, flowing from French horses as well as from French soldiers lying alongside. Power lines and a roadside religious waystation stand in the background, which is manned by German troops moving about the death and destruction.

While the panzers forged ahead at great speed, the infantry slogged on foot. Behind them their supplies of ammunition, food and fuel plodded along via horse-drawn wagons and carts. The movement of the mechanised forces was often hampered by the slower moving foot traffic as well as the corpses of the horses still tangled in their wagon harnesses. The lack of mechanised support vehicles and the mismatched reliance on horses for those all-important logistical duties significantly contributed to Germany's ultimate military failure.

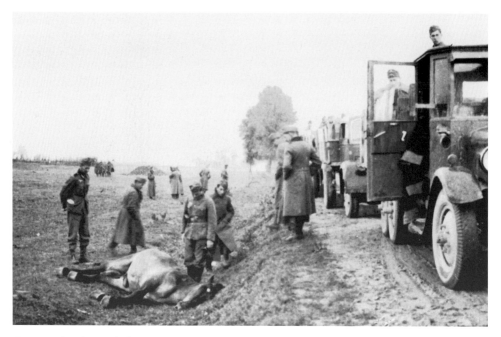

Compassion in a Ditch
Somewhere in France, and with a long line of heavy trucks parked nearby, German soldiers stop to ponder the death of a horse.

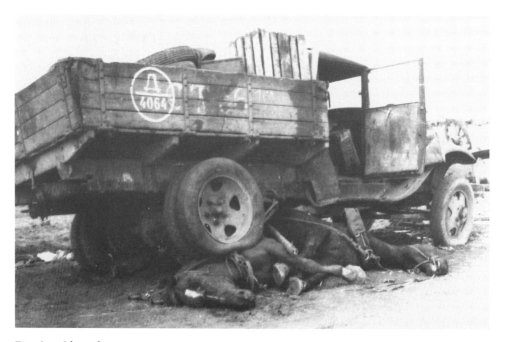

Russian Obstacle
Among a sea of battle debris, a Russian military truck has rolled onto the bodies of two horses. The driver has fled his vehicle and cargo, leaving the scene for a German soldier's camera to record.

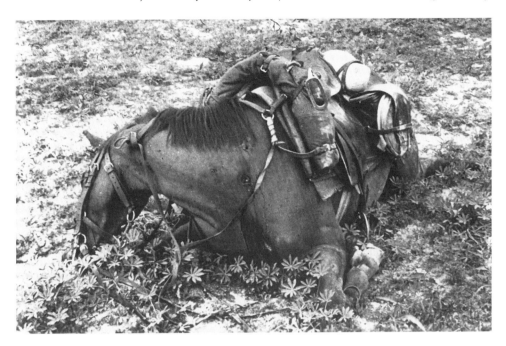

Above: **Shrapnel Wound**
A fully kitted cavalry horse has
dropped to its knees in death – the
several wounds in its neck indicating
artillery fire.

Right: **Impromptu Grave**
On a French city street recently
visited by war, a group of soldiers and
support personnel display varying
expressions of emotion as they peer
down into a bomb crater. One has
noticed the photographer and struck a
theatrical pose.

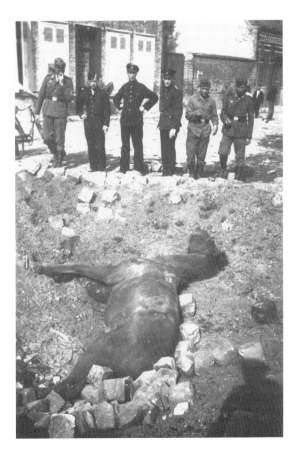

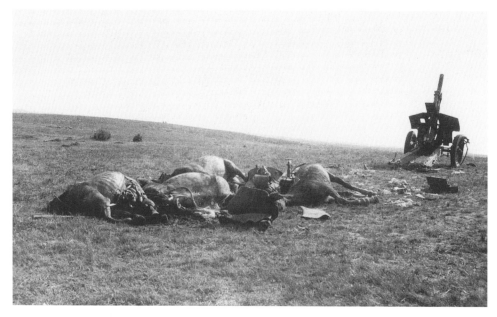

Weapon Intact
The remains of four Russian horses lie in a heap near the field canon that they may have towed into position before coming under fire.

'War Library'
One of a series of booklets prepared for German youth, and published each Sunday by the Steiniger Co. of Berlin, bears the cover title 'We Chase the Soviets'. The image depicts German Messerschmitt aircraft strafing a horse-drawn Russian Army wagon. The interior page carries a subtitle relating to the story's purported contributor, which reads, 'German fighter pilot experiences in the fight against the world enemy.'

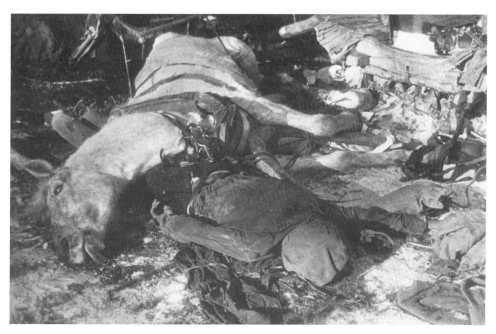

Shared Fate
A wagon horse and its Russian driver lie together in death at Lidija-Kessel, Russia.

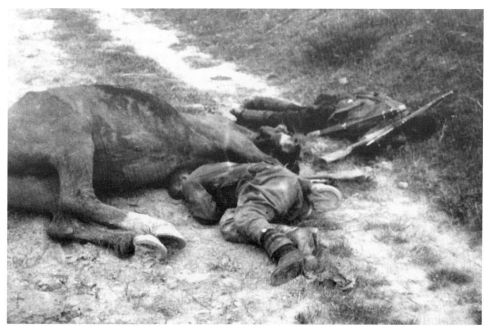

Seeking Shelter
Two Russian soldiers lie close to a horse, its hoof prints still fresh in the soil. The Russian Mosin-Nagant standard infantry rifle rests across the head of one of the men – perhaps posed there by the German photographer.

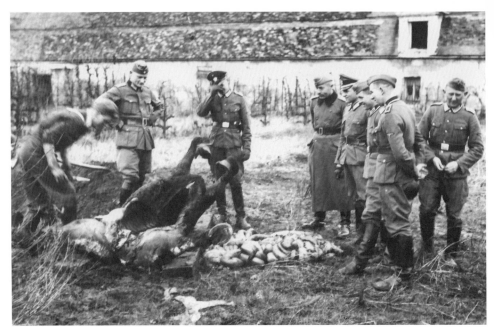

Butchery
A knife-wielding soldier approaches a horse that has already been disembowelled prior to becoming food for the German soldiers, who stand about wearing a variety of expressions.

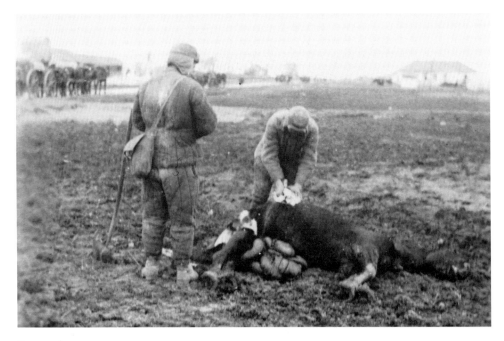

Scavenging
A German soldier records Red Army POWs cutting meat from a dead *panje*. Some 3 million Russian POW would be left to starve to death by their German captors.

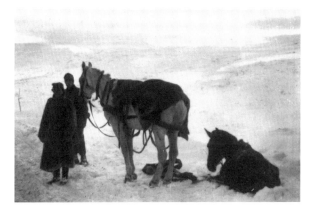

Murmansk's Icy Graves

Located 125 miles from the Arctic Circle, the indigenous native word 'Murmansk' translates as 'Edge of the Earth.' Here, both man and animal have reached the end of their tether.

Seeking to cut the supply lines to the Soviet Union from British and American naval convoys delivering much-needed war material, German forces sought to occupy the ice-free ports of Archangel and Murmansk, located in the Litza Valley, during the June 1941 invasion of Russia. The German effort to stem the flow of Allied supplies failed. Between August 1941 and May 1945, a total of some 1,400 Murmansk merchant ships made the crossing, during which eighty-five merchant vessels and sixteen Royal Navy warships (two cruisers, six destroyers and eight other escort ships) were sunk by the Germans.

Struggle in the Snow

Soldiers attempt to free a horse floundering in the Eastern Front's icy grip.

Along the Salla Front, German and Russian soldiers alike would face an awful winter. However, the Germans were far worse off as they had not been issued with winter clothing. In the sub-zero blizzards, Russian and German forces put aside their hostility and huddled together in an effort to survive the cold. Their bodies were often discovered frozen together, bonded in deathly brotherhood. In the Salla arena of conflict, 8,000 of the Russian forces died, with only 192 surviving to be taken as prisoners. German losses included a pioneer company (combat engineers), of whom 482 of the 494 men died.

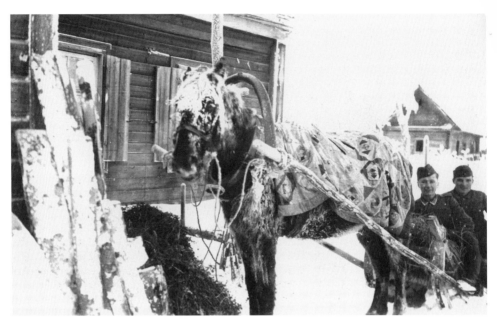

Quilted Horse: Murmansk Campaign – Winter 1941
German soldiers sit in a sled pulled by an ice-encrusted *panje* horse, which has been provided with a quilt for protection against the cold. Though the soldiers are smiling for the camera, they are wearing their summer uniforms, as issued to German troops when the invasion of the Soviet Union started in the warm month of June.

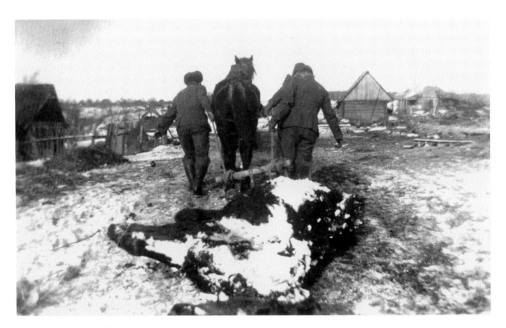

Not to be Wasted
The frozen body of a horse is dragged along, which will eventually become food for the ravenous troops.

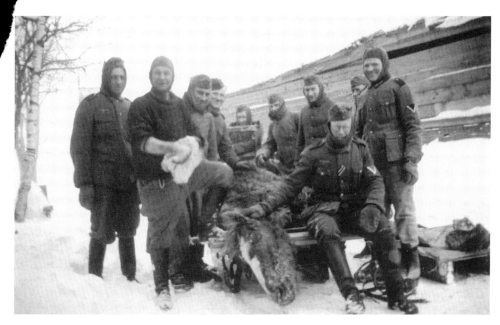

Photo from the Eastern Front – First Winter
Corporals and privates, still wearing their summer uniforms and bundled up as best they can against the cold, pose for a photo with their next meal. They seem well-fed and in good spirits… but the winters in Russia will grow far worse and far deadlier for both man and beast.

Final Fate

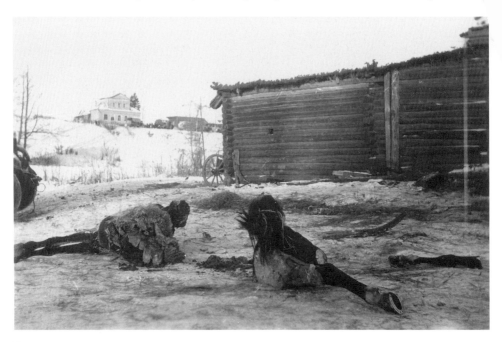

Remnants
The butchered remains of a horse lie in the Russian snow. The large estate visible in the distance is now serving as a German command centre.

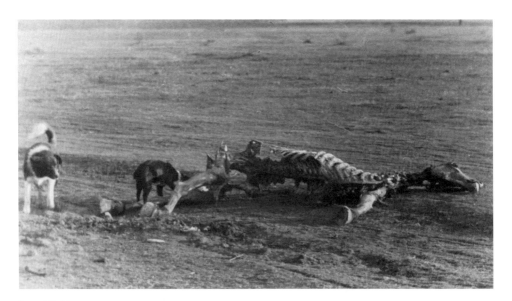

Last Pickings
On 19 January 1943, Field Marshal Friedrich von Paulus, the commander of the doomed Sixth Army, sent the following message when surrounded by Soviet forces at Stalingrad: 'The last horses have been eaten up.' While many of the Army Group's horses had been previously evacuated before the encirclement, some 25,000 had remained with the troops. In all, 300,000 Germans and 300,000 Italian and Romanian allies were left dead in the snow.

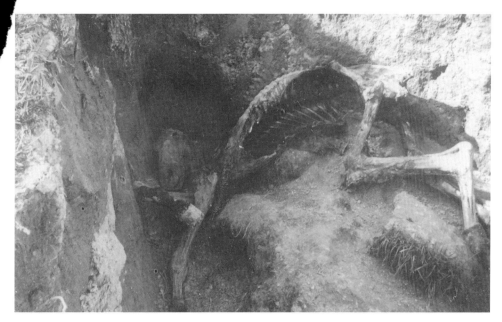

'Neben in Polnische Wagen'
Somewhere in Poland, a German soldier stops to photograph the remains of a horse that are almost human in appearance. The neatly inked notations on the reverse translate to the cryptic phrase 'Next to the Polish Wagon'.

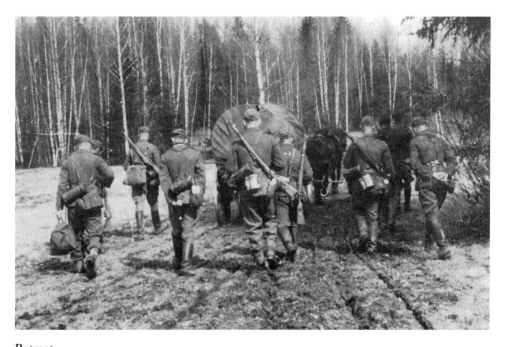

Retreat
Following a horse-drawn wagon, infantry soldiers trudge along a rutted Russian forest road on the long walk back to Germany.

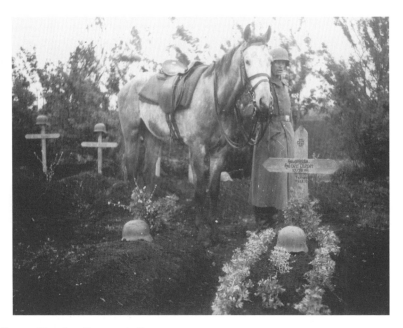

Farewell on a Russian Summer's Day
Sometime in May 1942, a comrade has brought Hubert Pieper's Trakehner cavalry mount to his grave. The forty-four-year-old Sergeant Major of *Jägerbataillon 191* was killed during the German second summer offensive as von Manstein's Army entered the Crimea.

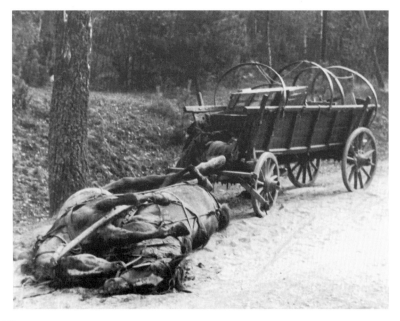

Final Toll
The number of horses and mules used by the German military eventually amounted to 2.75 million. Of them, an estimated 750,000 died during the war. The number of Polish and French horses that perished is unknown, but Soviet losses are estimated at several million.